Hagi

FAMOUS CERAMICS OF JAPAN 11

Hagi

Ryōsuke Kawano

KODANSHA INTERNATIONAL LTD.
Tokyo, New York, San Francisco

Translated by Robert N. Huey

Distributed in the United States by Kodansha International/USA Ltd.,
through Harper & Row, Publishers, 10 East 53rd Street, New York,
New York 10022.

Published by Kodansha International Ltd., 12-21 Otowa 2-chome,
Bunkyo-ku, Tokyo 112 and Kodansha International/USA Ltd., with
offices at 10 East 53rd Street, New York, New York 10022 and at
The Hearst Building, 5 Third Street, Suite 430, San Francisco,
California 94103.

LCC 83-47620
ISBN 0-87011-594-4
ISBN 4-7700-1094-x (in Japan)

Library of Congress Cataloging in Publication Data

Kawano, Ryōsuke.
 Hagi.

 (Famous ceramics of Japan; 11)
 Translation of: Hagi.
 1. Hagi pottery. I. Title. II. Series.
NK4168.H33K33 1983 738.2'7 83-47620
ISBN 0-87011-594-4 (U.S.)

Hagi Ware

THE ORIGINS AND EVOLUTION OF HAGI WARE

Whether as a community where houses from the Edo and Meiji periods retain their original appearance, as a place that is redolent with the fragrance of citrus orchards, or as the production center of Hagi pottery, the town of Hagi seems to have become all too famous in recent years.

Hagi, a castle town built by the Mōri clan on the delta where the clear-flowing Abu River divides into the Matsumoto and Hashimoto rivers and flows into the Japan Sea, has the air of a quiet town frozen in the late Edo period (1615-1868). Progress seems to have passed Hagi by. Tree-clad Mt. Shizuki (Mt. Oshiro) casts its beautiful reflection onto the Japan Sea. The town is cradled on the east, south, and west by dark green mountains and embraced by two rivers; the sky overhead is blue, the air perfectly clear.

Crossing the Matsumoto River, which forms the eastern boundary of the old castle town, and continuing along the road that used to link isolated Abu County with the Sekishū region, one sees the Shōin Shrine, and the Tōkō-ji, the ancestral temple of the Mōri clan, on the right. A climb up the gentle slope of Nakanokura brings one to the foot of Mt. Tōjin, where the site of the old fief kiln called Saka lies enveloped in foliage. A left turn at the Shōin Shrine brings one to the site of the old fief kiln of Miwa, deep in the woods at the foot of Mt. Mutagahara.

Nestled in the blues and greens of the surrounding mountains, rivers, and sea, the kilns of Hagi have a three-hundred year history, and the ware is still being fired today.

The area around Fukawa is also splendid. Thirty kilometers west of Hagi, the Fukawa River flows through the town of Nagato, then empties into the Japan Sea at scenic Ōmi Island. In a valley cut by the Sōnose River (one of the Fukawa's tributaries),

about one kilometer southeast of Yumoto Hot Springs, can be found the Sakakura, Sakata, Shinjō, and Tahara kilns. These kilns still operate today as they did in feudal times.

Each of these Hagi kilns is surrounded by the peace and beauty of nature. There are very few places in Japan that are as blessed as the Hagi kilns by clean, and even lovely, natural surroundings. This is why such beautiful tea ware is produced here.

The Origins of Hagi Ware

Toyotomi Hideyoshi's second invasion of Korea, in the late sixteenth century, has been called the "Pottery War." The lords of western Japan who participated were all on the hunt for the much-prized Korean Ido teabowls, and they brought back with them a large number of Korean potters.

These feudal lords were responsible for setting up and maintaining many regional potteries during the early Edo period. The Hosokawa clan's Agano ware, the Kuroda clan's Takatori ware, the Shimazu clan's Satsuma ware are examples of this phenomenon. Similarly, Hagi ware was originated by the local clan's Korean potters. Kilns were started at Nakanokura, in Matsumoto Village, near Hagi Castle, and at Sōnose, in Fukawa Village, to the west of Hagi, to produce pottery for the use of the Mōri clan, ruling family of the Hagi domain. It was a pottery steeped in the traditional techniques of Korea's Yi dynasty.

The founders of Hagi ware were the brothers Yi Sukkwang and Yi Kyung, and the group that formed around them. Yi Sukkwang, the elder brother, was head of a family line of potters, and he was ordered to Japan by Hideyoshi at the time of the latter's 1593 invasion of Korea. He was brought to Osaka and placed in the service of Mōri Terumoto.

Mōri Terumoto was one of Hideyoshi's most trusted generals. At that time, he was in charge of

5

administering the eight provinces of western Honshū, a position of great power. He was also a disciple and close friend of Sen no Rikyū, the man who perfected the *wabi* style of tea ceremony, and Mōri was a tea master himself. Hideyoshi apparently summoned Yi Sukkwang on Mōri's behalf, so that the latter might benefit from Yi Sukkwang's pottery skills. Mōri put Yi to work making pottery at his headquarters, the castle town of Hiroshima. Later, at the time of the 1597 Korean invasion, the younger brother, Yi Kyung, and others were also brought over to Japan.

In 1600, Mōri fought with the western (losing) army in the Battle of Sekigahara, and his domain was whittled down to the area of modern-day Yamaguchi Prefecture. In 1604, he moved from Hiroshima and installed himself in Hagi Castle.

The Yi brothers also made the move and were ordered to establish a kiln at Nakanokura, in Matsumoto Village. This was the beginning of what is now called Hagi ware.

The first recorded use of the term "Hagi ware" appears in the *Kakumeiki* (an early Edo period diary containing a great deal of information on tea activities of the time), wherein one entry, dated 1668, refers to a "Hagi teabowl." However, from ancient times, pottery in the Hagi fief was divided into types, such as "Matsumoto ware," "Fukawa ware," "Fukawa teabowl ware," and "Sōnose ware." In fact, it is only since the Meiji period that the term "Hagi ware" has become widely used, and even now it is sometimes subdivided into Matsumoto Hagi ware and Fukawa Hagi ware.

The Beginnings of Matsumoto Ware
The brothers Yi Sukkwang and Yi Kyung built their kiln at Nakanokura, in Matsumoto Village. The feudal authorities granted them the use of nearby Mt. Tsutsumi for gathering firewood. Yi Sukkwang was given five assistants, paid a substantial rice stipend, and was given the title of Craftsman of the Fief. He was also ordered to survey and restore old fief kilns. In his last years, he went to restore the old kiln at Sōnose, in Fukawa Village, and is said to have died there. His grave and a memorial pagoda can be found on a hillside outside Fukawa, in present-day Nagato.

Yi Sukkwang married after coming to Hagi and had one son, but Yi died while the son was still very young, and the child was raised by Yi Kyung, his uncle. As an adult, the son was known as Yamamura Shinbei Mitsumasa, but in 1625, the Mōri clan lord Hidenari granted him the name Sakunojō, along with the same salary his father had received. He was then put in charge of all fief pottery activities, as his father had been.

Yi Kyung took the name Sakamoto (later simply Saka) Sukehachi after building his kiln and acted as his elder brother's assistant. But later, several months after Yi Sukkwang's son had received an official name from the domainal lord, Yi Kyung was granted the name Kōraizaemon, along with

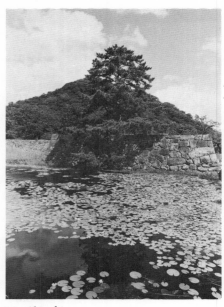

Mt. Shizuki

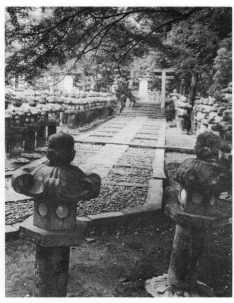

The compound of Tōkō-ji temple

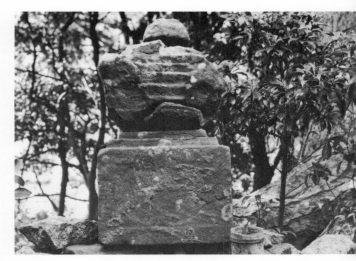

This is said to be the tomb of Yi Sukkwang.

three assistants and a fair-sized rice stipend. He died in 1643 at the age of fifty-eight.

Somewhat before this, in 1640, Yamamura Sakunojō (Yi Sukkwang's son) murdered a warrior named Watanabe at Hokke-ji temple, in the castle town. He thereafter became a priest, taking the name Shōan. He was granted a house in Furuhagi, and, accompanied by two of his students—Yamazaki Heizaemon and Kurasaki Gorōzaemon—moved there from Nakanokura.

Potters Supported by the Fief

There were a number of other Matsumoto ware potters who were more or less contemporaries of the Yi brothers. Administrative records of the domain list the following eight potters as employed by the fief in 1645: Ichiemon, Saka Sukehachi (Yi Kyung's heir), Kurasaki Gorōzaemon, Matsumoto no Sukezaemon, Yamamura Shōan (Yi Sukkwang's son), Matsumoto no Kambei, Matsumoto no Suke'emon, and Matsumoto no Hachizaemon. The Yi brothers had already died when these records were written, and their offspring, Yamamura Shōan and Saka Sukehachi, had taken their place. Ichiemon, being a local potter, was given the highest rank. Kurasaki Gorōzaemon and Matsumoto no Kambei shared a common lineage. Matsumoto no Sukezaemon and Matsumoto no Suke'emon were both from the Akagawa family. All four are thought to have been brought to Japan from Korea, along with Yi Kyung, by the Mōri family and to have subsequently followed Yi Sukkwang to Hagi from Hiroshima.

Of these potters, Yamamura Shōan received the highest stipend, and from this, along with the fact that in 1647 Saka Sukehachi and five others enrolled as Shōan's apprentices, it is clear that the status of the Yamamura family was quite high.

The Beginnings of Pottery at Sōnose—Fukawa Ware

When Yamamura Shōan moved from Nakanokura to Furuhagi, he took along with him as assistants two of his senior apprentices—Yamazaki Heizaemon and Kurasaki Gorōzaemon. But shortly thereafter, Yamazaki Heizaemon asked the fief authorities for permission to move to another province. Because they considered his skills important to the domain, they refused his request, but had him instead start a new kiln at Sōnose, in the village of Kawakami, an area in the castle town that had recently been built up. He was still under the supervision of the Yamamura family, and it appears that his pottery line died out with him.

In 1653, Shōan's other senior apprentice, Kurasaki Gorōzaemon, and his relative Kambei asked the authorities for permission to start their own kiln. The authorities would agree as long as they chose a location in the domain, so they requested Yi Sukkwang's former site, Sōnose, in Fukawa village. The fief authorities supported the project even to the extent of giving them permission to cut firewood in the forests around nearby Dainei-ji temple and providing labor for the actual construction of the kiln.

But the new kiln had trouble getting started, and

Dainei-ji temple

Community kiln site in Fukawa

in 1657, Akagawa Sukezaemon and Akagawa Suke'emon moved from Nakanokura to help out. With their help the kiln was finally successful. Thus all the apprentices from the Yamamura family kiln at Nakanokura in Matsumoto moved to the Sōnose kiln in Fukawa. In 1656, Yamamura Shōan's son, Mitsutoshi, was designated heir to the family pottery line. In 1657, he, too, moved to Sōnose, and received a house and the title "Director of the Sōnose Kiln" from the fief. Later that year, his apprentices submitted a pledge to the fief authorities that they would not move to other locations. Thus Fukawa pottery began to be produced.

Matsumoto Ware—the Miwa and Saeki (Hayashi) Kilns

The Yamamura family fortunes went into a decline. Their top apprentice, Kurasaki, became head of a branch family, the Akagawa. And in 1658, a year after his son Mitsutoshi had established himself at Fukawa, Yamamura Shōan was murdered in revenge at the gates of Hokke-ji temple by the son of the man Shōan had killed there eighteen years before. This left only two fief kilns (kilns supported financially by the domain) at Matsumoto: the one operated by the Saka family and that of Ichiemon. The Saka family presently assumed the Yamamura's former position as "Directors of the Matsumoto Kilns." With Yi Sukkwang's line of apprentices having moved to Fukawa, Matsumoto became rather quiet. At length, Lord Mōri Tsunahiro, taking an active interest in the promotion of fief pottery, appointed, in 1663, two new names as official fief potters: Miwa Chūbei Toshisada and Saeki Hanroku Sanekiyo.

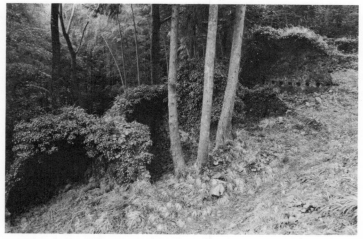

Higashi-no-Shin kiln site of the Akagawa family (this kiln was built in 1763)

The founder of the Miwa family had been brought to Japan from Korea by Shishido Mototsugu (one of Mōri Terumoto's commanders), and began producing pottery in Akana (in present-day Shimane Prefecture). His son, Akana Uchikuranosuke, set up a kiln at Komaru-yama, near Hagi Castle, when the Mōri clan moved to Hagi. *His* son, the above-mentioned Toshisada, who became Miwa Kyūsetsu I, in turn, was recognized for his skills by the fief authorities and was sent to Kyoto to study Raku ware. He infused his Hagi ware with a traditional Japanese pottery style. There is another theory regarding the origins of the Miwa house, which claims the forefather was a resident of Yamato (present-day Nara Prefecture) named Minamoto Tazaemon.

Saeki Hanroku was the second son of a family that had served as castle builders for the Mōri clan since the latter's inception. Hanroku was a superb potter and was asked to start a kiln at Mutagahara. Hanroku's grandfather, Yamato-no-Kami Motonobu, had earned his reputation by building fortifications for the Japanese during the invasion of Korea. He married a Korean woman and returned to Japan. Thus, the connections between Korea and the early Hagi fief potters are very deep.

The second-generation Miwa potter, Yahei Toshinari, and the first-generation Saeki potter, Hanroku, both became apprentices to the third-generation Saka potter, Shimbei. Under the supervision of the Saka family, they breathed new life into Matsumoto ware, which had foundered when its most accomplished practitioners had moved to Fukawa. Thus, during Tsunahiro's rule as head of the Hagi domain, four fief kilns were established, and Hagi pottery was about to enter its golden age.

The Spread of Hagi Pottery

Early Hagi ware potters, with roots in the Korean ceramic traditions, moved about both within the domain and to other domains. One must not overlook the effect this spread of Hagi techniques has had on pottery in other areas.

The fief kiln in Izumo (modern Shimane Prefecture), which made Rakuzan ware, was established in 1677, when the local lord, Matsudaira Tsunataka, received permission from the Hagi authorities to bring in and employ Kurasaki Gombei. Gombei is presumed to be the son of either Kurasaki Gorō-

zaemon, originator of Fukawa pottery, or Kurasaki Kambei. He moved to Izumo along with another potter.

Susakaratsu ware, in Nagato, began when the local lord brought in Sakamoto Kizaemon, second son of Saka Kōraizaemon, with the aim of improving the indigenous Susa ware. Shōfūzan ware, in Chōfu, began when the Mōri family allowed Akagawa Sukezaemon to move there from Sōnose. And in Tokuyama, Kurasaki Kambei, a descendant of Kurasaki Gorōzaemon, was brought in from Sōnose and made master of the local kiln.

Porcelain Production in the Late Edo Period

During the first half of the Edo period, Hagi ware flourished under the patronage of the Mōri lords. During this time, the Saka family at Matsumoto and the Yamamura family at Fukawa produced their third, fourth, and fifth generations of potters, and the techniques of Raku, Iga, and Shigaraki pottery were introduced by the Miwa kilns. Concurrently, Hagi ware rapidly developed from its earlier Korean style toward a more Japanese type of pottery.

It was during this time, in 1705, that the third-generation potter Saka Shimbei donated a teabowl to the Tōdai-ji temple in Nara on the occasion of the dedication of that temple's Great Buddha Hall.

From the middle of the Edo period onward, *sencha* (leaf tea using teapots and tiny cups, as compared to the powdered green tea [*matcha*], which was whisked in large bowls in the formal tea ceremony) became popular. Even the Hagi potters began to produce quantities of *sencha* utensils.

In 1744, another Miwa kiln potter, the fourth-generation Kyūsetsu Toshiyuki, went to Kyoto to study Raku techniques. Meanwhile, the Saeki family, whose name had been changed to Hayashi, lost the patronage of the fief when one of their line illegally left the domain, and by 1817 the Saeki-Hayashi kiln had ceased to operate. This left the Saka and Miwa kilns as the only official fief-supported producers of Matsumoto ware.

By the early 1800s, porcelain was sweeping Japan, and in the village of Obata, near Hagi castle, seven porcelain kilns appeared. Following the lead of the potters of Kyoto and northern Kyushu, they produced white porcelain utensils for daily use.

The appearance of white porcelain as a rival to the tea ceremony pottery produced by the fief kilns was indeed a crucial event. For a time, the porcelain prospered due to the fief policy of promoting locally made goods. But by the end of the Edo period it was in decline.

In the midst of this, another trend appeared. Teabowls resembling the type reserved for use by the feudal heirarchy began to be sold on the open market in Hagi. In 1815, the authorities tried to curb this practice by promulgating laws prohibiting such activities and reserving Hagi ware's special clay—called Daidō clay—for the exclusive use of official fief kilns. But judging from the fact that similar prohibitions were announced in 1832, it is clear that the practice continued.

However, in the case of Fukawa ware, unlike Matsumoto ware, private kilns were allowed to function alongside the official fief kilns from the very beginning. But these kilns, too, were subject to strict supervision by the fief officials. However, by 1693, management of the Fukawa kiln had shifted down from fief officials to the village headman. The management of the Fukawa pottery thus now was involved in the life of the farming community as well as with pottery production.

Nonetheless, the Akagawa family continued to prosper, as evidenced by their building the Higashi-no-Shin kiln in 1763. The Yamamura family, who passed down the title of Director of the Sōnose Fief Kilns through their heirs, continued to collect the stipend they had received since the time of Yi Sukkwang. But in 1774, the fifth-generation head of the family, Mitsunaga, fell ill and died at the age of sixty-three while his petition to the fief authorities to make his adopted son, Gen'emon, the heir to his line was still unresolved.

But even before the mourning period was over, Gen'emon was involoved in a violent dispute with a retainer of the influential Ihara family and was sent into exile. Thus Mitsunaga's family died out, and along with it the Yamamura line of master potters.

Subsequently, the Sakakura family succeeded to the Yamamura family's position as Directors of the Sōnose Fief Kilns. This was by virtue of their having one of their family members adopted by the Yamamuras, which they proved by a family genealogy that Mitsunaga had submitted to the fief authorites in 1767.

By late in the Edo period, members of the Saka-

kura and Akagawa families continued to be designated Master Potters of the Fief, and the Sakakuras were put in charge of the Fukawa fief kiln. But jurisdiction over the fief kilns had passed down to the village level, and since official financial support had declined, such things as kiln additions or repairs had to be undertaken by the potter families themselves. The potters gradually became unable to keep up with their tax burden, and in 1819 the Kurasaki, Akagawa, and Sakakura families jointly petitioned the authorities to resume official fief support. This support seems never to have materialized.

By this time, porcelain kilns were spreading throughout the area, and in 1830 the Kurimoto porcelain kiln was built in Fukawa. The Sōnose master potters petitioned the village headman to close down the rival kiln, but in vain. Furthermore, rural samurai retainers cooperated in the production of pottery for everyday use at Itamochi Kamaya in Fukawa. Industry was thriving in the region, but to the fief potters it represented a significant competitive threat, and they took a defensive posture toward it.

At the end of the Edo period, kilns began proliferating in the tiny Sōnose valley, where the active kilns reached twelve in number. The Sakakura family had split into five branches, each with its own kiln. Hayashi Hanroku, who had earlier left the area, returned under a new name (Kobayashi) and moved to Fukawa Yumoto with his son Miura Ryōhei, and another "name" kiln disappeared.

Hagi Pottery in the Meiji Restoration

When Japan shed its feudal system in the event known as the Meiji Restoration, Hagi pottery saw some rather difficult times.

In 1882, Saka Kangaku (the ninth generation of the Saka family) petitioned the prefectural government for financial support for Hagi pottery. His petition reads, in part:

> Since the time of my ancestors, the generosity of the lords of the domain allowed my family to engage in the production of ceramic ware. They were so kind as to give us financial support for our kilns, workshops, and materials, and they paid for the pottery we produced as well. In return, we supplied them with pottery to meet their needs. However, since the disappearance

of the feudal system, we have been obliged to operate on our own, and must pay all of our expenses ourselves.

As a result of this petition, the prefecture lent Saka Kangaku a fair sum of money. But the incident clearly shows how difficult circumstances had become for the old fief kilns. The potters now had to cultivate new markets. One of the best ways to do this was to win a prize at one of the frequent industrial exhibitions that were part of the government's policy to foster the growth of industry.

At about this time, the Obata porcelain kiln was revived, and as the production of pottery became a commercial venture in the castle town, many new kilns sprang up. In the midst of this activity, the Saka and Miwa kilns, which were determined to protect the old traditions of tea ceremony ceramics, went through some remarkably hard times.

In the late 1800s, the Hagi potter Yamato Sakutarō (studio name, Shōroku) started a kiln at Miyano, in Yamaguchi Prefecture. His descendants later got together and established the site as the Yamaguchi Hagi ware Shoroku kiln.

Fukawa ware also saw difficult times through the late nineteenth and early twentieth centuries. Of the twelve fief kilns that had existed at the end of the period, most went out of production. Only four kilns—Sakakura, Sakata, Tahara, and Shinjō—survived.

It is especially sad that the Kurasaki line, descended from an apprentice of Yi Sukkwang, died out, and that the Akagawa name disappeared. Actually, in the case of the Akagawa family, only the name was lost. In order to acquire samurai status in the transition

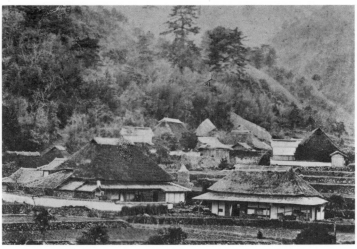

Sōnose in 1908

from the Edo to the Meiji periods, they changed their name to Tahara and Shinjō. Thus the two families are partly related to the original Akagawa progenitors, Sukezaemon and Suke'emon.

Sencha, which enjoyed a further increase in popularity after the Meiji Restoration, began to lose its following by the early 1920s, as did white porcelain, which had enjoyed a brief revival. Powdered tea (*matcha*) was gradually recapturing interest, but it was not until after the Second World War that Hagi tea ceremony ceramics experienced a real renaissance.

FIEF KILNS AND HAGI POTTERY TECHNIQUES

The Mōri Family and Tea Ceremony

Old Hagi tea wares achieved fame precisely because they had the appearance of Korean ceramics. The Korean techniques belonged to the potters Yi Sukkwang and Yi Kyung, who had been brought to Hagi from Korea. But the ones responsible for fostering these techniques on Hagi soil were Mōri Terumoto, first of the Mōri line of feudal lords of the Hagi domain, and his descendants. That Terumoto was an acknowledged tea master has already been mentioned. In fact, all the military commanders attached to the Mōri family were tea experts.

Mōri Hidemoto, at first Terumoto's adopted son, but later (after Terumoto had a natural són) given lordship of the Chōfu region in the Hagi domain, had a close relationship with Furuta Oribe, Japan's most celebrated tea master after Sen no Rikyū. When Hidemoto returned from the invasion of Korea, he brought back with him teabowls he had

had made in Korea. And in 1640, he invited all the feudal lords, from Shogun Tokugawa Iemitsu on down, to a tea gathering, which came to be known as the Great Shinagawa Tea Ceremony. It is because of Hidemoto that the Oribe style left its mark on Hagi ware, and it is safe to say that these two men, Hidemoto and Oribe, are the "fathers" of Hagi tea ceramics, though one should not overlook contributions made by two military commanders in the service of the Mōri family, Kikkawa Hiroie and Kobayakawa Takakage. Subsequent generations of Hagi lords of the Mōri line continued their patronage of the tea ceremony and had a profound impact on Hagi ware.

Among these lords, Shigetaka (the seventh generation) had a particular taste for elegant things. In his later years he retired to his Eiun villa (in the modern-day town of Hōfu) to pursue his interests. He brought the tea master Kawakami Fuhaku (top student of Joshinsai, head of the Omote Senke tea school) from Edo, and also engaged such masters as Takeda Kyūwa for instruction in tea. Shigetaka made his own teabowls and had a teahouse called Kagetsu-rō built on the grounds of his villa. He later presented this teahouse to Takeda Kyūwa, and it subsequently came into the possession of Shinagawa Yajirō. It now stands, restored, in the precincts of the Shōin Shrine. It remains a rare and valuable legacy of the *shoin* style of tea ceremony. (This is an older, more conservative type of tea ceremony than the more famous *wabi* style of Sen no Rikyū.)

A similar *shoin* style teahouse can also be found, restored, on the grounds of the ruins of Hagi Castle. It is called the Susuharai (literally, "house-cleaning")

Susuharai teahouse

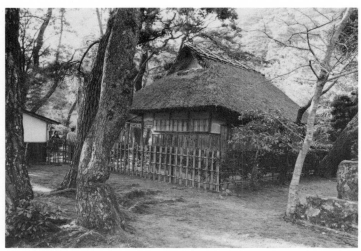
Hananoe tea hut

teahouse, so named because the lord stayed at the residence of its owner while Hagi Castle underwent periodic cleaning. Also preserved on the Hagi Castle grounds is the Hananoe tea hut, where the thirteenth-generation Hagi lord Mōri Takachika was said to have spent much time planning and carrying out official business. Today this hut is used by Hagi tea masters for their monthly tea ceremonies. The Way of Tea is still very much alive in the town of Hagi.

Pottery Techniques of the Fief Kilns
The fief kilns were administered by the domain's Office of the Warehouse Superintendant. Whenever the Hagi lord commissioned ceramic works, it was customary for the potter concerned to request and receive the necessary materials from the fief's Warehouse Office. Kilns, workshops, and equipment were also provided for through financial subsidies from the fief.

The following is an invoice submitted to the Officers of the Warehouse by the potter Saka Shimbei in 1733. It gives a good indication of what went into the firing of a kiln:

> Pleased be advised:
> Item: 40 bundles of kindling
> Item: 60 bundles of split firewood
> Item: 1 nine-foot piece of forked wood with three branches
> Item: 50 bundles of straw
> Item: 50 sacks of Obata clay
> Item: 2 laborers a day, for 100 days
> Item: 3 sacks of Akawahake clay, and 1 assistant for 100 days
> Item: 6 2/3 pounds of white lead powder
> Item: 2 reed mats
> Item: 2 sacks of glaze base
> Item: 8 sacks of Daidō clay
>
> The above-mentioned items were used in compliance with a fief commission. This invoice is submitted for your inspection.
> To: the Officers of the Warehouse
> 10th Month, 2nd Day

Fire, earth, and the wheel are considered essential for pottery. Hagi ware is fired using pine wood split into very small pieces.

As for clay, the basic material that ultimately determines the nature of the pot, the Hagi potters from the very beginning used local Obata clay as

their basic clay. This is a red clay with a low iron content and when fired produces a reddish-purple color known as *beni Hagi* ("crimson Hagi"). It is used even when slip is to be applied. Mitakeyama clay, a white kaolin type, is also used today, mixed with Daidō clay to increase its refractory quality. Another type often used is Mishima clay, a red clay that is light and not too sticky. It can be used for any kind of pot, but is frequently the choice for pieces that are to have slip applied to them. But the most important clay for Hagi ware is Daidō (dug in modern-day Hōfu City), a white clay full of tiny pebbles. The characteristics of this clay closely resemble those of the clay used in Korean bowls. It is because of this clay that tea masters were prompted to praise the "feel" of Hagi ware. And it is also one of the reasons why Old Hagi ware is often mistaken for Korean ware. Furthermore, it is because of the quality of its clay that Hagi ware has been ranked second (behind Raku, and ahead of Karatsu) as a tea ceremony pottery.

Incidentally, Hagi ware made by the first three generations of Matsumoto ware potters is referred to as Old Hagi. There is a popular theory that Old Hagi was only made with local clay, and that the use of Daidō clay did not begin until after 1716. But Daidō clay was in fact used from the very beginning, as evidenced by the Ido teabowl in Plate 6, and the *higaki* Hissen type bowl owned by the Miwa family, shown in Plates 12-13. Since Hagi ware was officially supported by the fief, it seems reasonable to assume that the potters did not have to rely solely on local clay, but from early on had access to Daidō clay, which was dug between the towns of Hagi and Hōfu. It is true, however, that Daidō clay became more frequently used as time went on. In any case, the relationship between Old Hagi ware and Daidō clay needs further study.

In addition, a number of other clays were used by the kilns at Nakanokura and Fukawa.

The color of Hagi ware clay ranges from dark-brown to white, the quality from hard to the soft, light Daidō.

Hagi glaze colors form a rich variety: white, loquat (a pale orange), black, amber, yellow, and celadon green. The loquat-orange color projects a warmth that has always charmed tea masters.

At both Matsumoto and Fukawa, the potters produced a special white color by using rice-straw ash glaze. At Fukawa, they also used special glaze

mixtures known as *samé* ("shark") and *namako* ("sea cucumber"), and a glaze remarkably like that used in Takatori ware, though this glaze has since fallen into disuse.

Nowadays, Hagi potters mainly use a mixture of feldspar powder and wood ash to produce a transparent glaze, and the white rice-straw ash mentioned above. The wood ash used to be obtained from local *isu* trees, but nowadays the *isu* wood must be brought in from Kyushu. Similarly, the feldspar was obtained locally in the old days, but now mostly comes from Fukushima and Aichi prefectures.

Hagi ware is formed, Korean style, on a kick wheel, and is fired in a multichambered *noborigama* ("climbing kiln").

Hagi Ware Forming and Decorating Techniques
Hagi ware as a tea pottery evolved from the Korean bowls that had caught the fancy of the tea masters of the Momoyama period and became prized teabowls in Japan. Naturally, in the beginning, Hagi potters copied the Ido, Goki, and Gohon types of Korean bowls. But almost immediately, they began to produce Tawara and Hissen type teabowls of the kind Oribe preferred. (These types are discussed in more detail below). Furthermore, under the influence of Raku ware, the Hagi pieces made at the Miwa kiln began to show a more Japanese flavor. As time went on, Hagi ware completely shed its Korean heritage.

Among Hagi tea ceramics, there are a very few pieces, called *e-Hagi* ("picture Hagi"), which show designs painted on with iron underglaze in the manner of "picture Karatsu" or "picture Shino" ware. However, leaving these aside, let us take a general look at the more characteristic shapes and decorations of Hagi ware.

Ido and Kairagi Types
There are many Hagi teabowls made in the Ido shape. There are a number of explanations for the origin of the name Ido—among them that it was a man named Ido Kakukō who first brought these bowls to Japan from Korea during the invasion of Korea; that Ido was a place name; or that Sen no Rikyū applied the name Ido to such bowls because they very deep, like a well ("well" being one meaning of the word *ido*) but none of these explanations is undisputable. It is now more or less

certain that the Ido shape originated in the vicinity of Jinju, Kyungsang Namdo. The teabowl known as Kizaemon, designated a National Treasure and in the keeping of the Kohō-an of Daitoku-ji temple in Kyoto, is representative of the "Grand" Ido type, while the bowl called Shibata, designated an Important Cultural Property and owned by the Nezu Art Museum in Tokyo is an example of "Green" (or "Small") Ido.

Hagi pieces of the Ido type closely resemble these two bowls in terms of glazing and clay, and true to the Ido style, they show such characteristics as "eye marks" (marks left by the fireclay pads placed between pieces stacked in the kiln) on the inside bottom or in the foot, a foot in the "bamboo node" shape, and the "crawling" or beaded effect of the glaze on the inside or outside of the foot.

The "crawling" glaze effect, generally known as *kairagi*, occurs when the glaze does not completely melt. Since the result resembles the dry bark of an old plum tree, the phenomenon is also called *baika hi* ("plum tree bark").

Old Hagi teabowls so closely resemble Ido bowls that in terms of shape and glaze it is easy to confuse the two. Yet Old Hagi Ido usually does not exhibit true Ido's expansiveness and freedom; rather, it is generally more proper and calm.

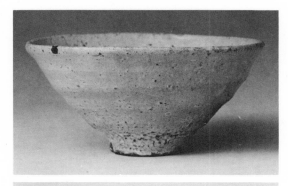

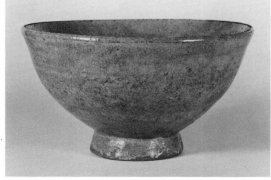

top: Ido teabowl from Korea; named Shibata (Nezu Art Museum)
bottom: Hagi Ido type teabowl

The Komogai Type and Chirimen Wrinkles

Komogai teabowls are so-called because a large number of bowls made in this manner were brought back from the Komogai (Ungchun) region of Korea by Ishida Mitsunari after the invasion of Korea. Komogai differs from Ido in that with the Komogai teabowl, the lip is flared outward, and a depression, called a *chadamari* ("tea pool") is found in the inside bottom of the bowl. The foot has a "bamboo node" shape, and, as a rule, the bowl is deep and well rounded. There are examples of the Komogai type even among the earliest Old Hagi bowls.

Often one finds a *chirimen* ("crinkled cloth," or, literally, "silk crepe") pattern inside the foot of a Komogai teabowl. This effect is an artifact of the method the potter uses to remove the bowl from the wheel and is much admired by men of tea.

The Gohon Type

The original Gohon bowls were made in Korea based on patterns or samples sent from Japan for reproduction. They are often referred to by the name of the person who commissioned them or designed the pattern (i.e., Rikyū-Gohon, Oribe-Gohon, Enshū-Gohon). One of the most famous of this type is the Gohon teabowl called *Tachizuru* ("Standing Crane"), which was based on a sketch made by Shogun Tokugawa Iemitsu. Because the clay used in Gohon bowls shows faint speckles of red, these bowls were greatly admired by tea masters.

Perhaps because Hagi clay is of a similar type, it, too, shows these red specks, which are referred to as *momiji* ("scarlet maple leaves"). This *momiji* effect frequently appears on bowls that have been covered with a simple transparent glaze.

Mishima, Tawara, Hakeme, and Kobiki Types

The term *mishima* in general refers to small incised or stamped patterns, which are then filled with slip contrasting in color to the clay body—usually white slip on a dark body. The name comes from the fact that to the Japanese these patterns resembled the minute script found on almanacs published by the Mishima Shrine in present-day Shizuoka Prefecture. From early on these pieces were used as teabowls in Japan, and Hagi potters made a great many of them, too.

For this slip-inlaid Mishima decoration, clay with a high iron content, such as Obata or Mishima clay,

was used. A pattern was incised or stamped into the clay, white slip was applied to the pot, which was allowed to dry, and the excess slip was scraped away to reveal the inlay clearly. Such inlay can also be seen in another style characteristic of Hagi ware—the *tawara* ("rice bale") style.

The *hakeme* ("brush mark") effect is produced by using a rough brush to apply white slip to the pot.

Kobiki is the term used for coating a dark clay body with white slip when the piece is leather hard. On top of this slip, a transparent glaze was applied.

Kobiki was one of Old Hagi's characteristic techniques. Except for early teabowls, which used clay from the town of Hagi, most other Hagi pieces display this technique. As a rule, Hagi *kobiki* pieces are suffused with a yellow color and have a mellow feeling about them.

Oni-Hagi: In another technique, rough sand was kneaded into the raw clay, producing a bold, even violent effect when fired. This is usually called *oni-Hagi* ("demon Hagi").

Beni-Hagi: In early times, the relatively iron-rich red clay from Obata was widely used and frequently yielded a red color. This type of Hagi ware is called *beni-Hagi* ("red Hagi").

Shira-Hagi: From long ago the Matsumoto and Fukawa kilns both used a white glaze made from rice-straw ash. The earliest pieces of this type show a cloudy yellowish-white color. Pots with this glaze are referred to as *shira-Hagi* ("white-Hagi").

Hai-katsugi or Hai-kaburi: Accidental ash-glaze effects that occur during firing are called *hai-katsugi* or *hai-kaburi* and were highly prized by tea masters.

"Split Foot" and "Cherry Blossom Foot": In the Gohon type and Old Hagi teabowls a notched foot, known as *wari-kōdai* ("split foot") is commonly found, and this became a characteristic of Hagi ware. The technique came from Korea, but because this break from the standard foot shape alters the harmony of the bowl, a popular theory held that the technique arose as a means of slightly damaging pieces so that the fief potters could sell off their surplus pieces to the common people. Another theory suggests that Korean potters notched the feet of the bowls to make them easier to stack up and tie together for transport or storage. Still another theory holds that

notching was done to improve the circulation of the flames through the bowl's foot during firing. Since the earliest examples of Hagi ware have two notches in the foot, this last explanation would seem to have some basis.

A teabowl named "Zekai-bō," associated with Furuta Oribe, is in the shape of a writing brush container (*hissen*) and has three notches in its foot. And the teabowl "Sakura Kōdai" (Cherry Blossom Foot; see Plates 10-11), owned by the Fujita Art Museum, has a foot that has been notched then shaped with the fingers to look like a cherry blossom. This bowl, too, reflects Oribe's taste.

Herame and Sogime: To compensate for Hagi ware's relative lack of decoration, marks (*me*) made with spatulas (*hera*) or shaping tools (*sogi*), were sometimes added to the body of the pot as accents. This, too, seems to reflect the Oribe style.

The Seven Faces of Hagi: This phrase is used to describe the fact that the qualities of Hagi teabowls change with use over time. The clay used in Hagi ware is porous, and the low-temperature firing rarely results in a fully-fired, vitreous glaze. Thus as a bowl is used, over a period of time moisture seeps into the cracks in the glaze, causing changes in the bowl's color and degree of shininess, and giving the bowl an ineffable character. This rare quality is particularly admired by tea masters.

The term is also used ironically to refer to the fact that Hagi ware is often mistaken for Ido or other types of Korean bowls.

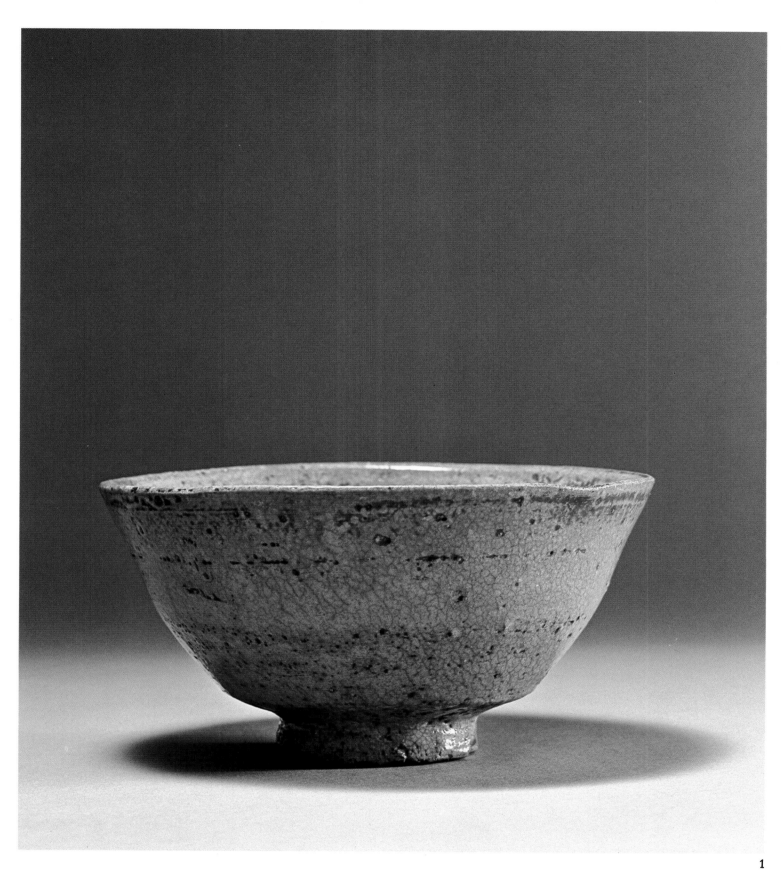

1

1. Old Hagi, Ido type teabowl, named Juzan. D. 15.3 cm., H. 8.0 cm.

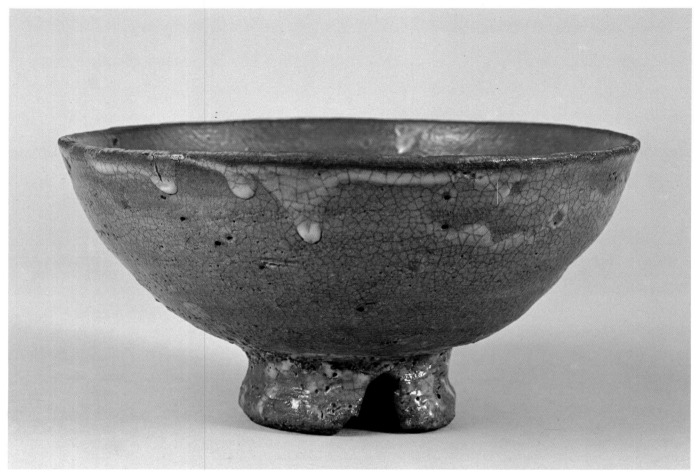

2

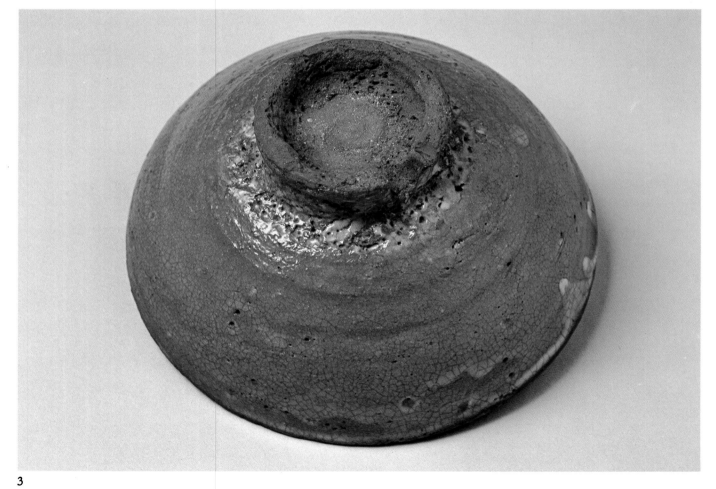

3

2, 3. Ido type teabowl with notched foot. D. 16.5 cm., H. 8.0 cm.

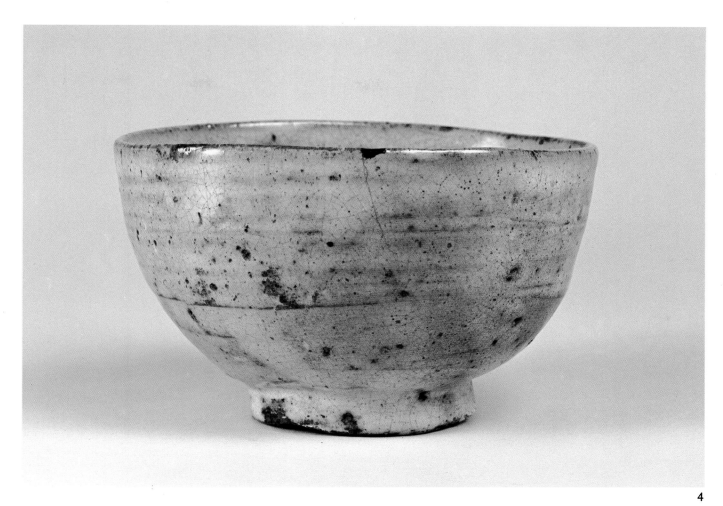

4

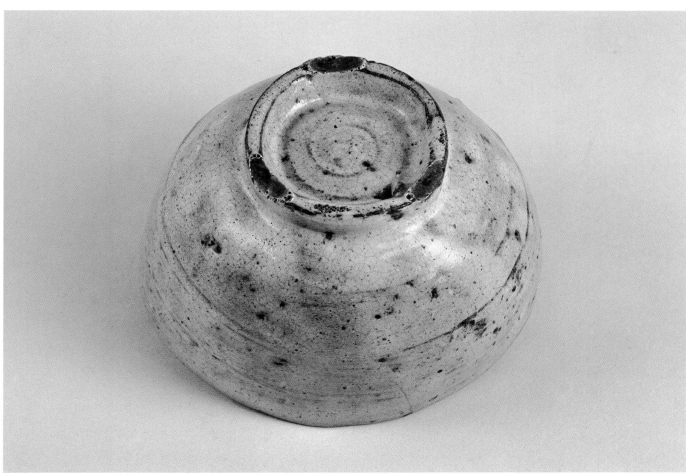

5

4, 5. Teabowl with white glaze. D. 14.3 cm., H. 8.8 cm.

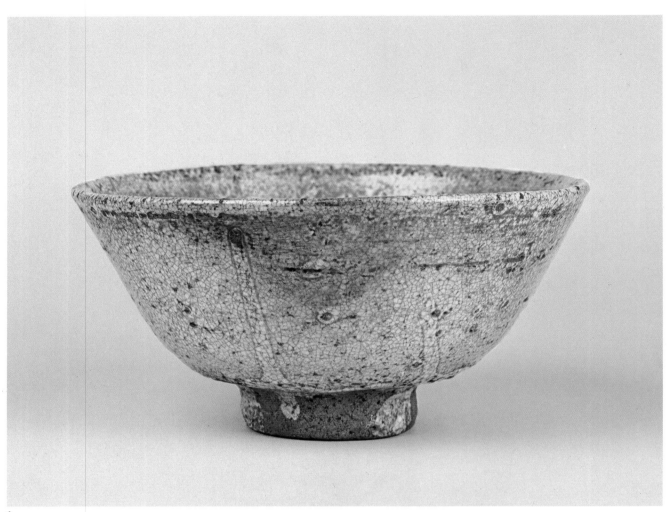

6

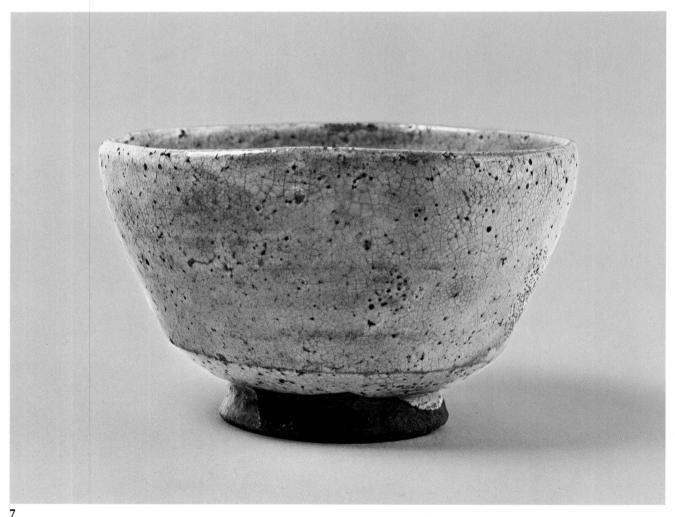

7

*6. Ido type teabowl, named Kan-un ("Lazily Drifting Clouds"). D. 17.2
cm., H. 9.0 cm. Hogyō-ji temple.*

7. Teabowl. D. 14.1 cm., H. 8.8 cm.

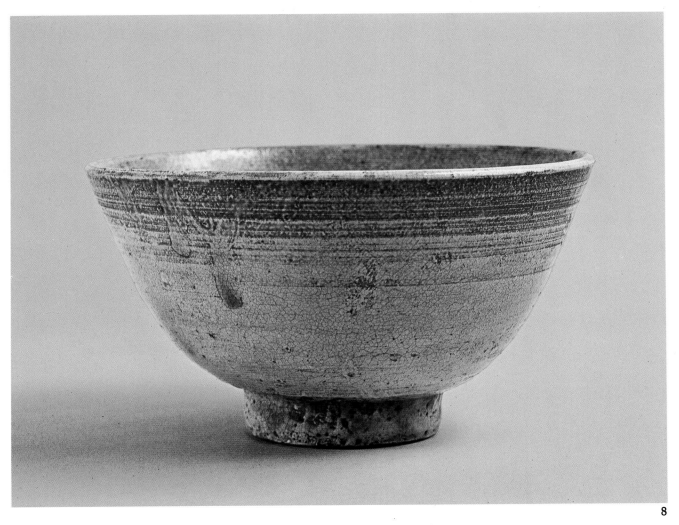

8

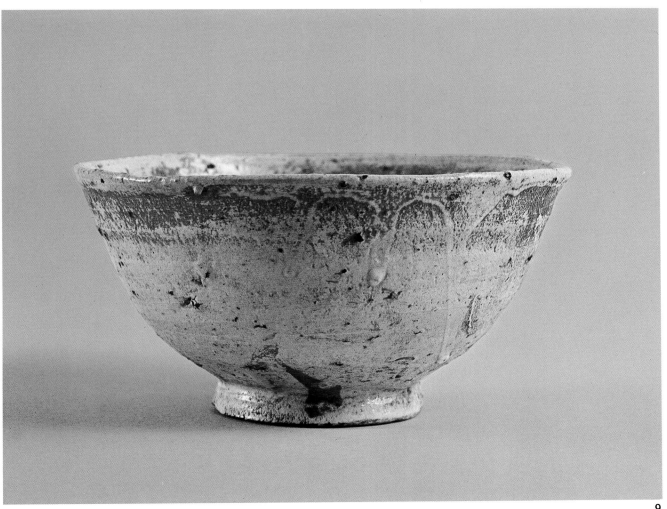

9

8. *Ido type teabowl. D. 14.2 cm., H. 8.3 cm. Mōri Museum.*

9. *Teabowl, named Shimamori. D. 13.9 cm., H. 7.4 cm.*

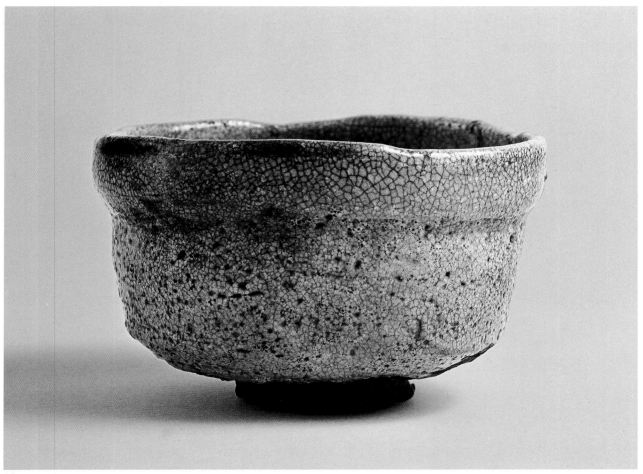

10

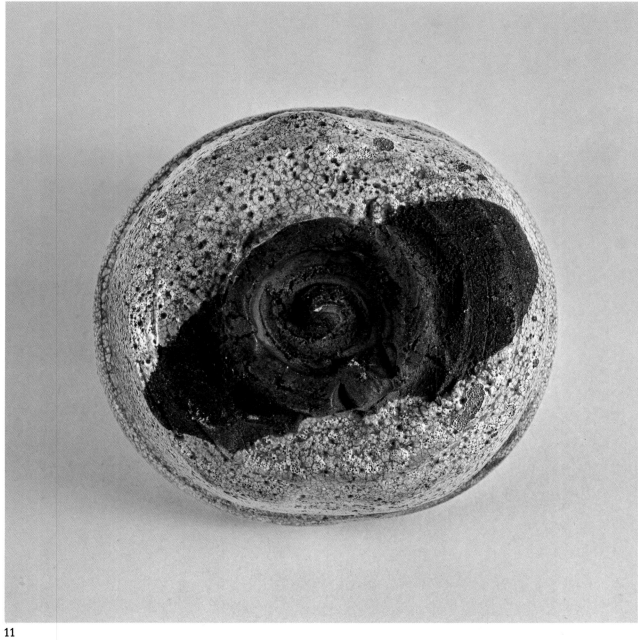

10, 11. Teabowl with hissen *(brush washer) shape and* sakura kōdai *("cherry blossom foot"). D. 12.4 cm., H. 7.8 cm. Fujita Art Museum.*

11

22

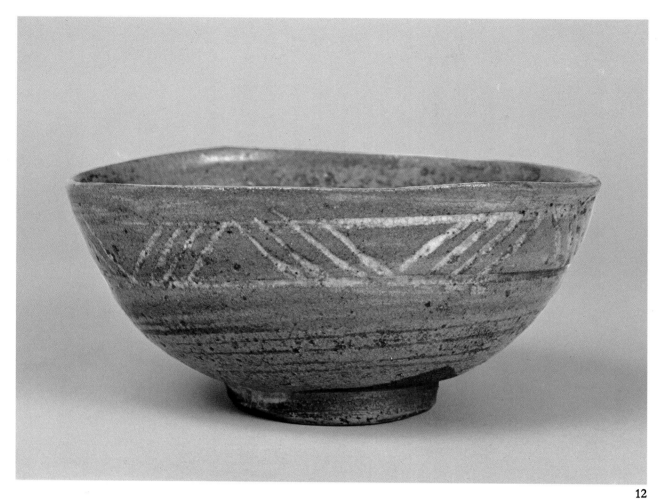

12

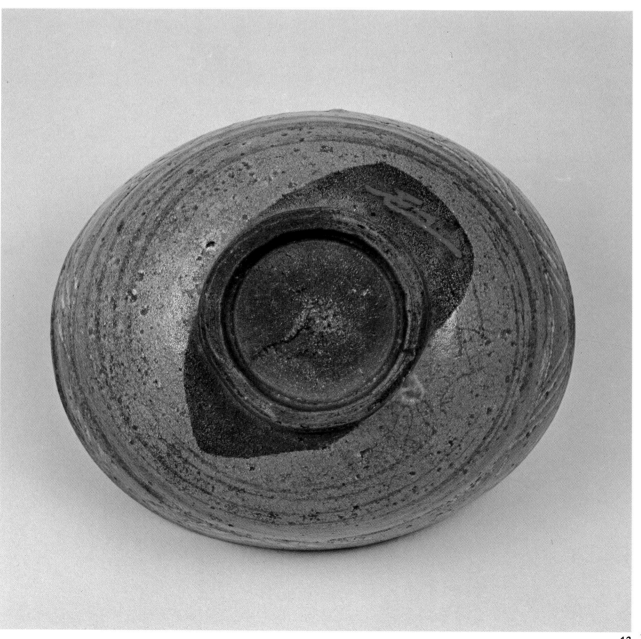

13

12, 13. Teabowl with hissen *(writing brush container) shape and* higaki *(cypress fence) pattern. D. 15.5 cm., H. 7.5 cm.*

23

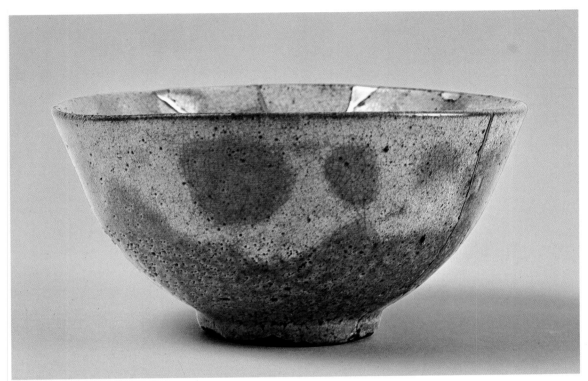

14

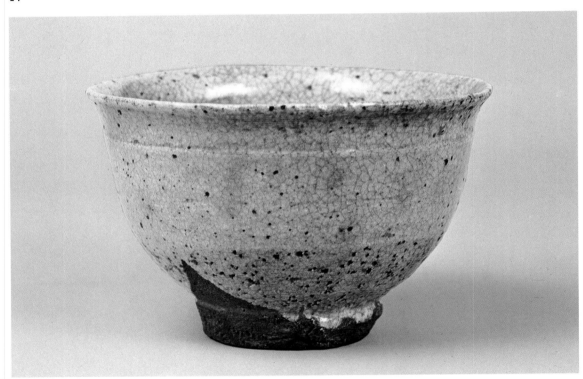

15

14. *Teabowl with "rain spots," named Tomaya ("Rush Hut"). D. 15.4 cm., H. 7.7 cm.*

15. *Copy of a* komogai *teabowl, named Fukura Suzume ("Fat Sparrow"). D. 13.8 cm., H. 9.0 cm.*

16. *Old* hagi wari-dawara *("split rice bale") teabowl, named Hōnen ("Bountiful Year"). D. 14.8 cm., H. 8.0 cm.*

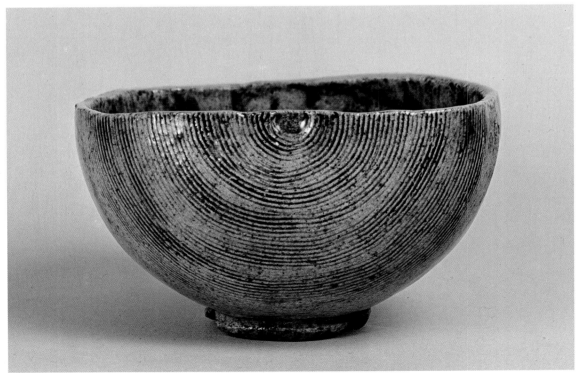

16

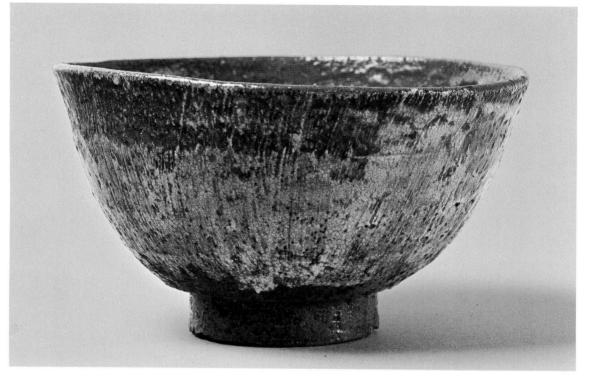

17

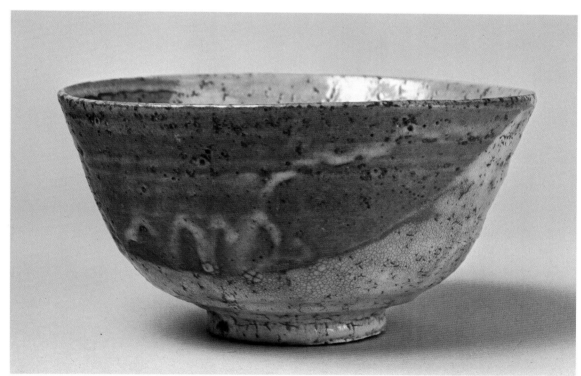

18

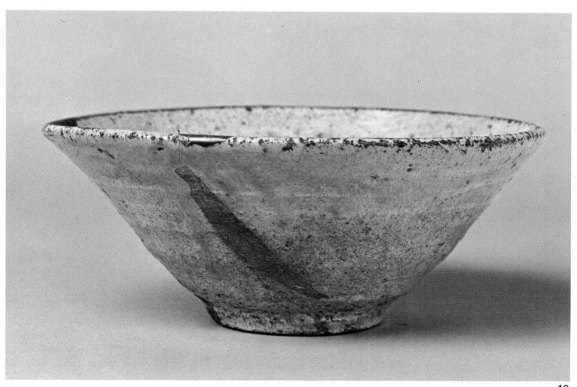

19

17. *Hakeme* ("*brush mark*") *teabowl. D. 15.0 cm., H. 8.8 cm. Omote Senke.*

18. Katami-gawari ("*half-clothed*") *teabowl, named Murasuzume* ("*Flock of Sparrows*"). *D. 14.2 cm., H. 7.8 cm.*

19. Kobiki *teabowl. D. 16.4 cm., H. 6.9 cm.*

25

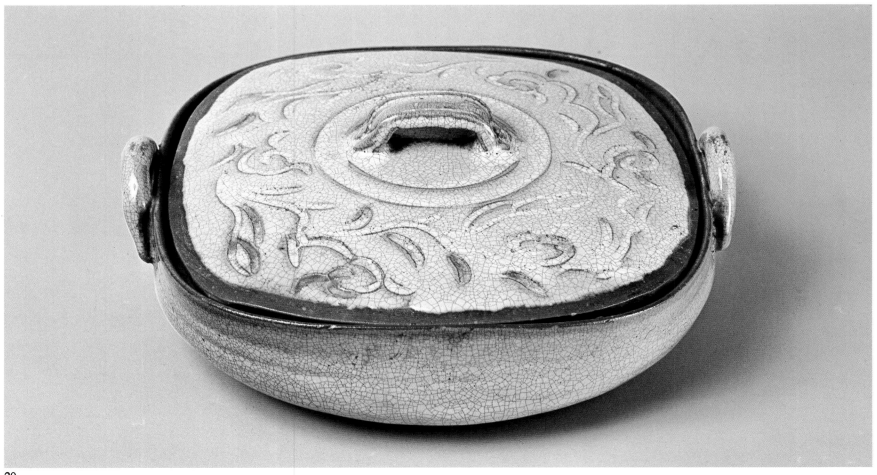

20

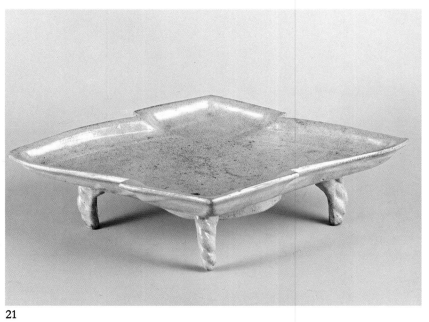

21

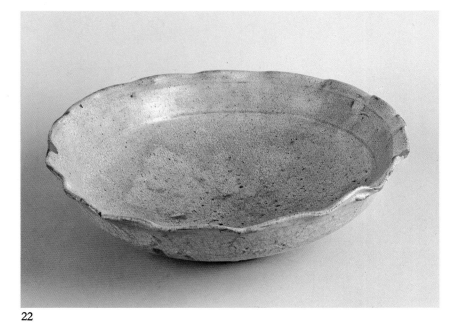

22

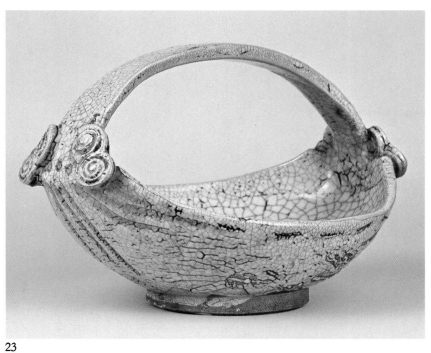

23

DISHES AND BOWLS (20-27)

20. Fukawa white-glazed, lidded pot, with incised design. 21.2 × 23.1 cm.

21. White-glazed, four-footed tea cake plate. L. 33.6 cm., H. 7.6 cm.

22. Bowl, D. 28.1 cm., H. 8.2 cm.

23. "Treasure boat" style bowl. L. 24.0 cm., H. 16.6 cm. Hongyō-ji temple.

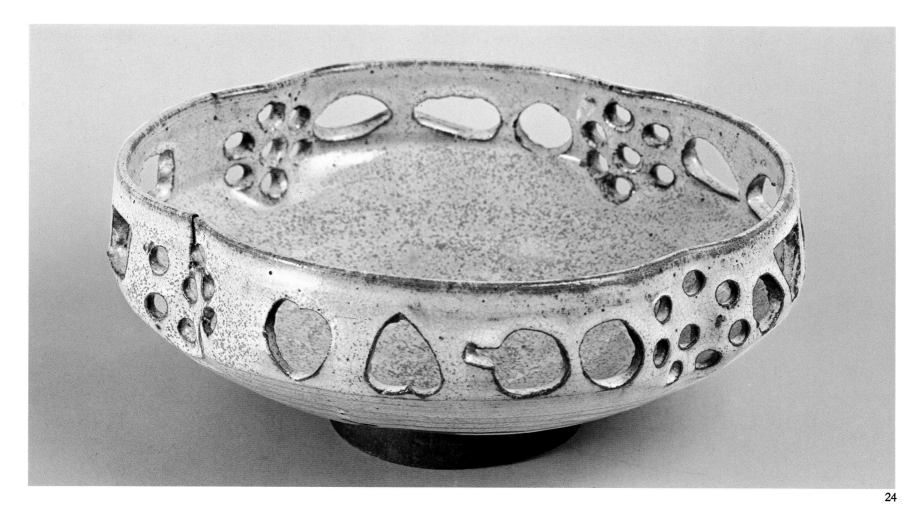

24

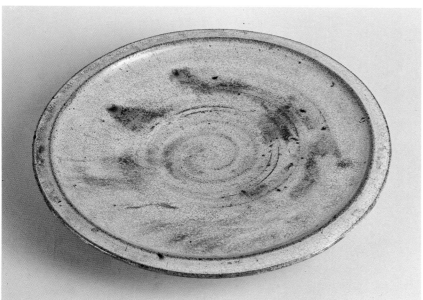

25

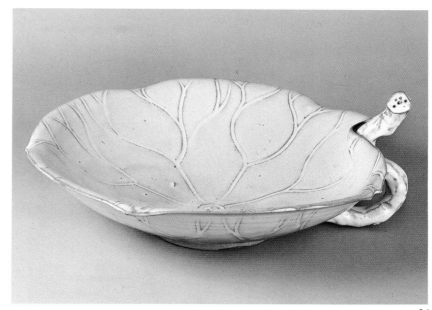

26

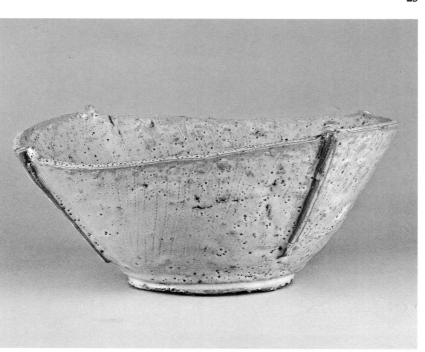

27

24. *Openwork bowl. D. 25.6 cm., H. 10.6 cm.*

25. *Fukawa white-glazed, flat dish. D. 26.8 cm.*

26. *Fukawa white-glazed, lotus leaf dish. D. 32.8 cm., H. 8.5 cm.*

27. *Four-cornered bowl. 24.6 × 19.0 cm., H. 11.2 cm. Tokyo National Museum.*

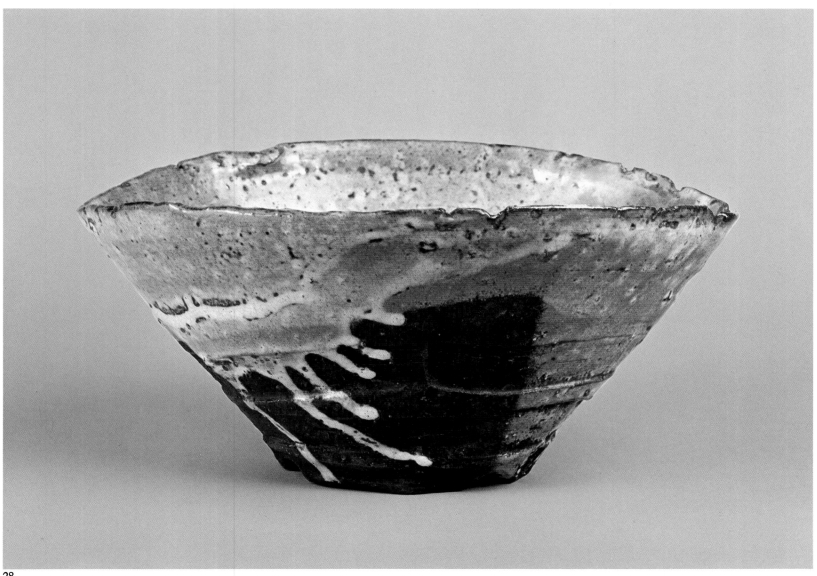

28

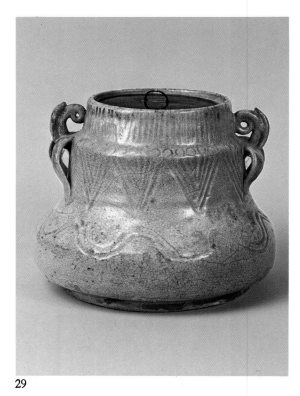

29

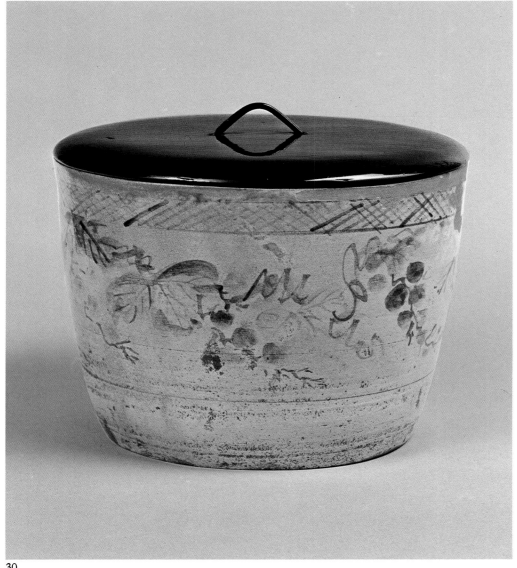

30

Water Containers, Vases, and Incense Burners (28-34)

28. "Umbrella hat" water container, named Takitsuse ("Cascading Waterfall"). 24.3 × 20.1 cm., H. 12.7 cm.

29. Eared water container. D. of body, 16.4 cm., H. 13.4 cm.

30. Water container. D. 19.1 cm., H. 13.7 cm.

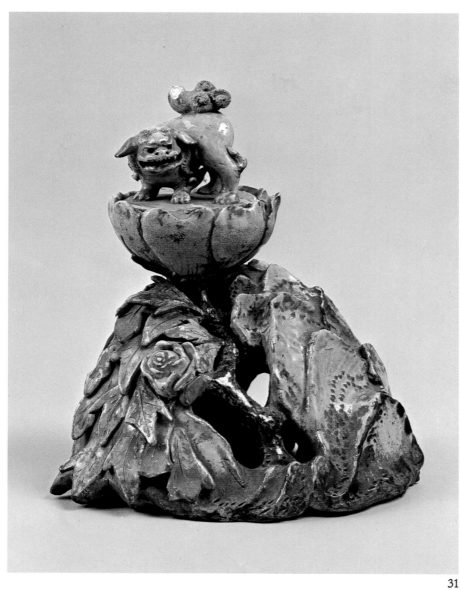

31

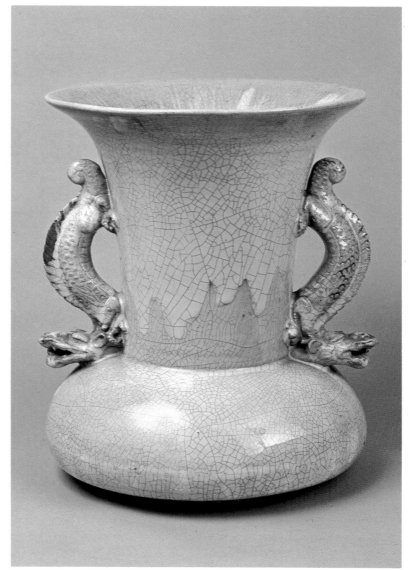

32

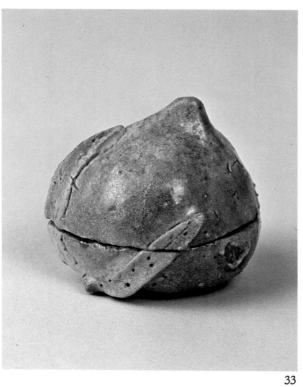

33

31. *Celadon incense burner with peonies and Chinese lion. H. 23.2 cm., D. at bottom, 21.7 cm.*

32. *White-glazed flower vase with dragon handles. D. of rim, 23.8 cm., H. 30.7 cm. Mōri Museum.*

33. *Incense burner in the shape of a peach. D. 5.8 cm., H. 5.5 cm.*

34. *Fukawa flower vase with namako ("sea cucumber") glaze. D. of body, 19.4 cm., H. 37.5 cm.*

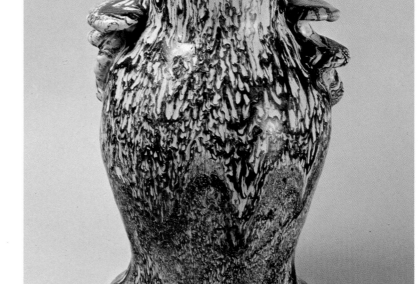

34

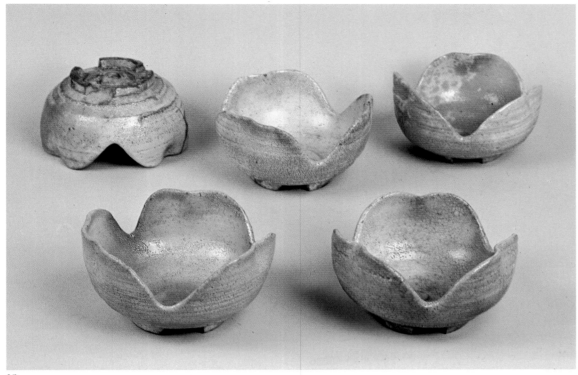

35

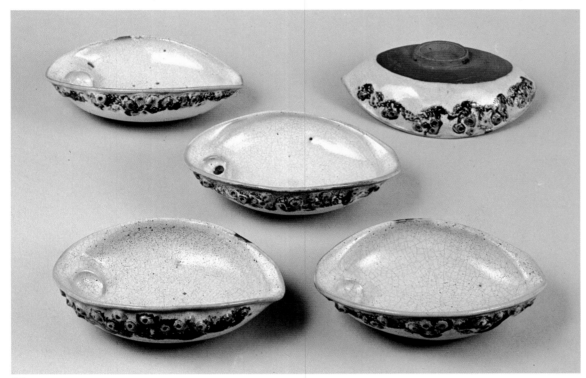

36

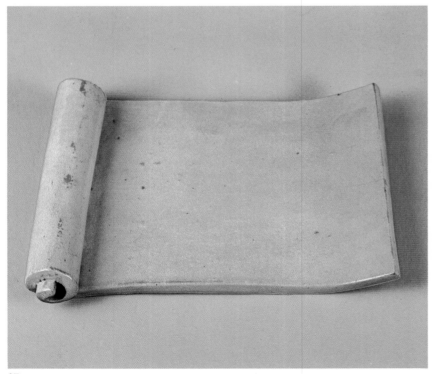

37

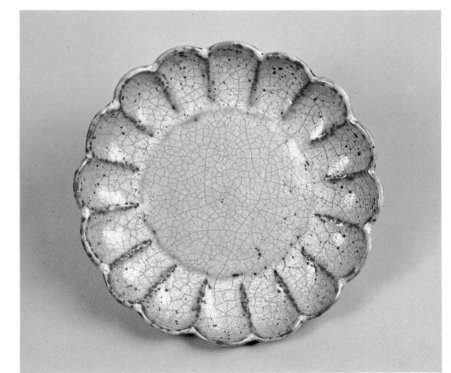

38

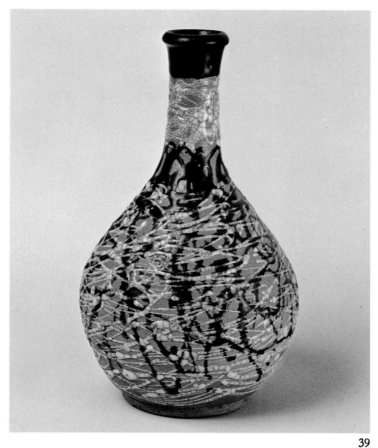

39

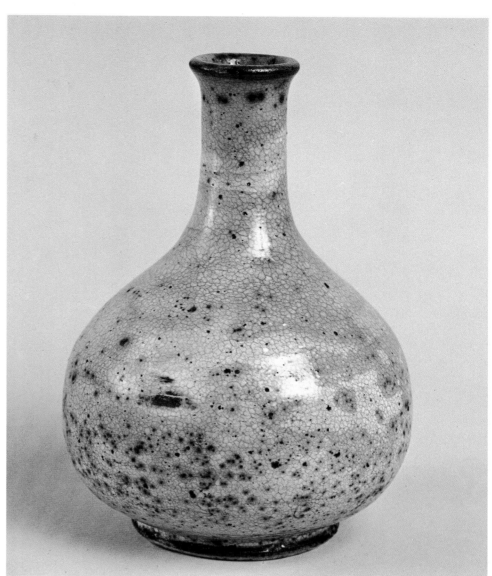

40

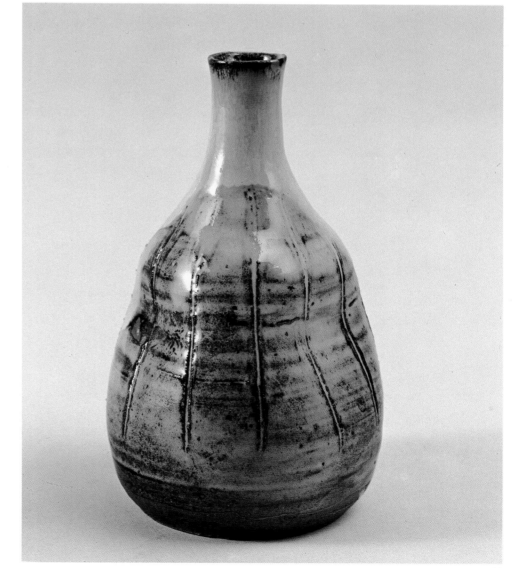

41

SAKÉ BOTTLES AND SERVING DISHES (35–41)

35. Serving dishes with split pod shape. D. 12.8 cm., H. 6.8 cm.

36. Fukawa serving dishes with abalone shape. L. 15.8 cm., W. 11.0 cm.

37. Flat dish in the form of a scroll. L. 19.4 cm., W. 13.8 cm.

38. Chrysanthemum plate. D. 16.5 cm., H. 3.0 cm.

39. Fukawa piragake *("scribble glazed") saké bottle. D. of body, 14.8 cm., H. 19.6 cm.*

40. Kobiki saké bottle. D. of body, 10.6 cm., H. 16.4 cm.

41. White-glazed saké bottle. D. of body, 9.8 cm., H. 18.0 cm.

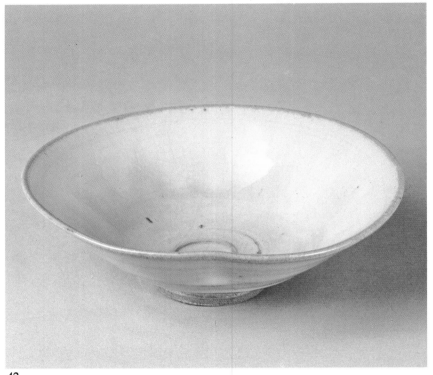

42

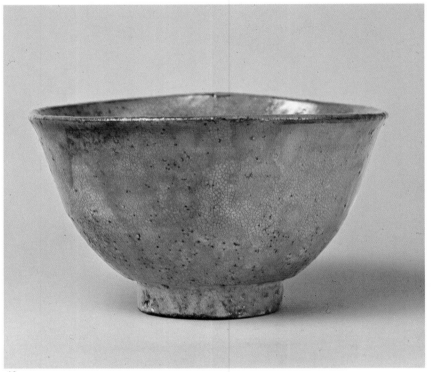

43

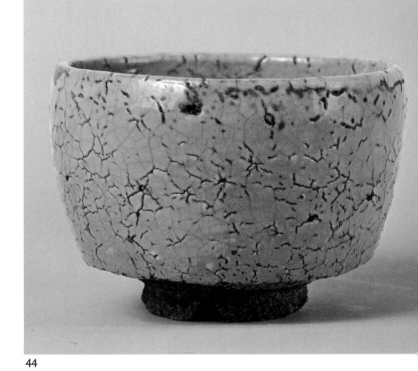

44

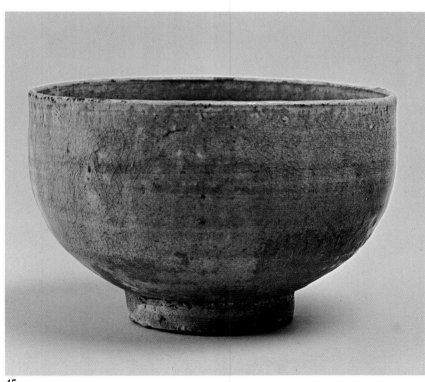

45

TYPES OF HAGI WARE (42-49)

42. White-glazed shallow teabowl. D. 15.5 cm., H. 4.5 cm.

43. Kobiki *teabowl. D. 14.0 cm., H. 8.5 cm.*

44. Beni-Hagi ("red Hagi") teabowl. D. 12.0 cm., H. 8.9 cm.

45. Celadon teabowl. D. 12.9 cm., H. 8.7 cm.

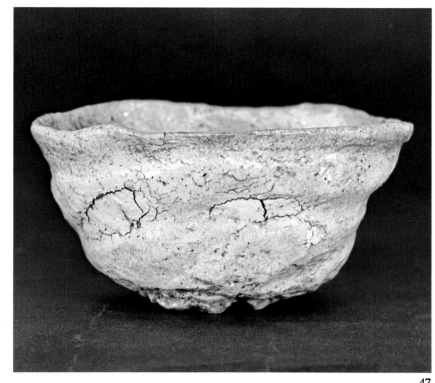

47

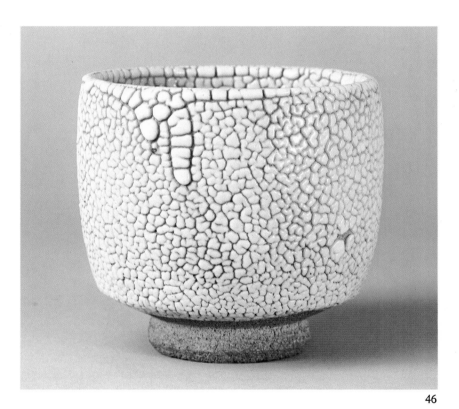

46

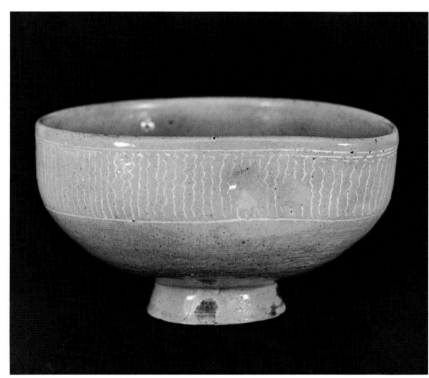

48

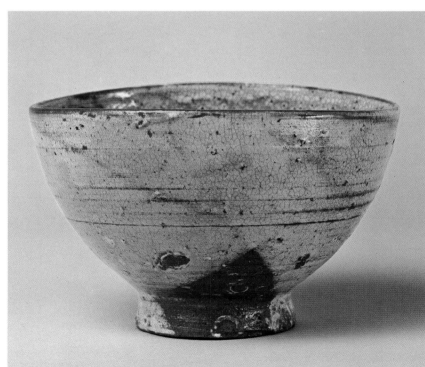

49

46. *Fukawa same ("shark") glazed teabowl. D. 9.8 cm., H. 9.5 cm.*

47. *Oni-Hagi ("demon Hagi") teabowl with hissen shape, named Chōryō (the famous Chinese warrior Zhang Liang). D. 14.5 cm., H. 7.7 cm.*

48. *Mishima type teabowl. D. 13.6 cm., H. 8.0 cm.*

49. *Gohon teabowl. D. 13.7 cm., H. 9.4 cm.*

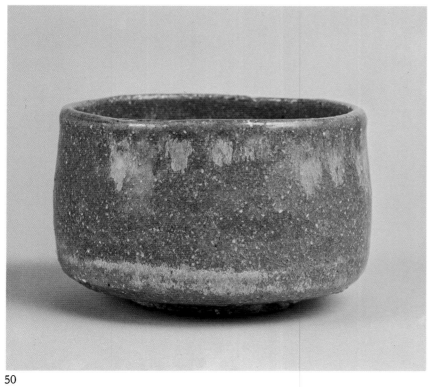

50

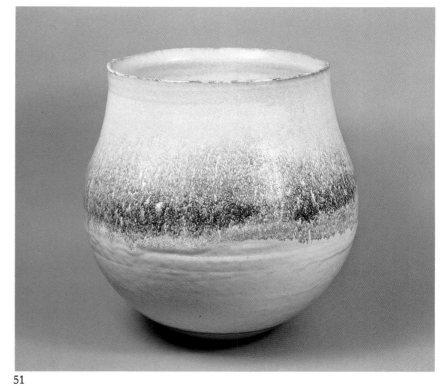

51

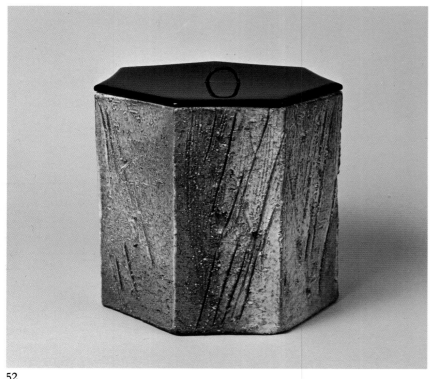

52

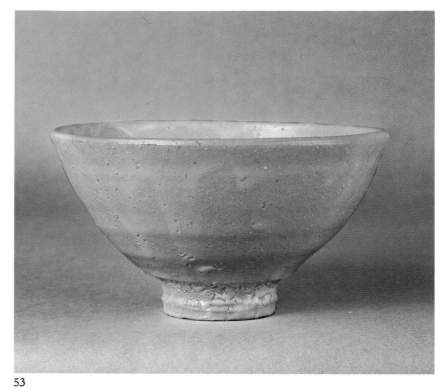

53

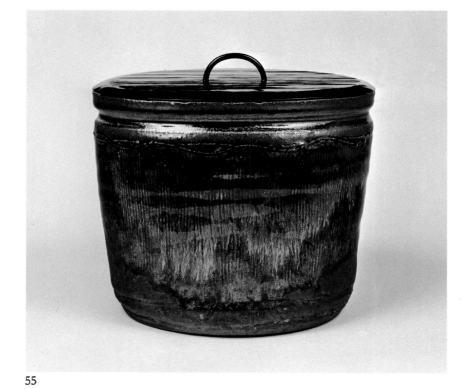

54

55

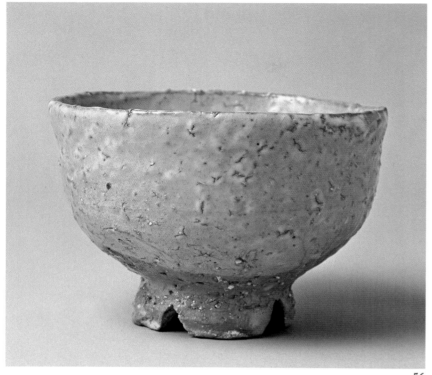

56

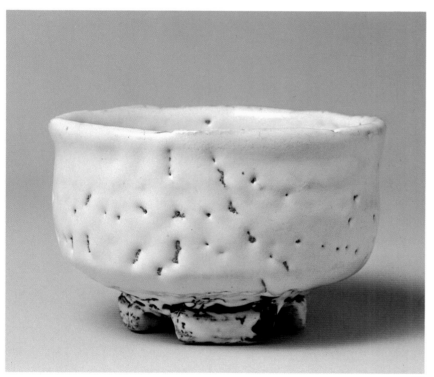

57

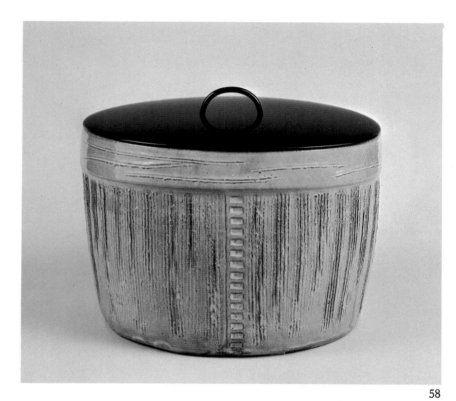

58

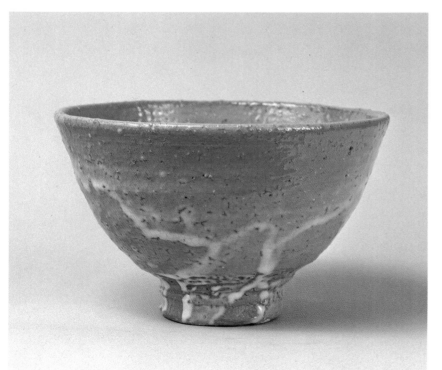

59

HAGI WARE BY MODERN POTTERS (50-59)

50. Low cylinder type teabowl, by Kōki Nosaka. D. 12.1 cm., H. 7.8 cm.

51. Wide-mouthed flower vase, named Gyō-un ("Clouds at Daybreak"), by Taibi Yoshiga. D. of body, 33.5 cm., H. 35.8 cm.

52. Seven-sided water container, by Yasuo Yamato. 17.6 × 16.2 cm., H. 16.3 cm.

53. Ido type teabowl, by Deika Sakata. D. 15.5 cm., H. 9.0 cm.

54. "LOVE," by Ryōsaku Miwa. H. 28.0 cm., W. 27.5 cm.

55. Korean style Karatsu water coantainer, by Tobei Tahara. D. 18.5 cm., H. 15.1 cm.

56. Teabowl, by Kyūwa Miwa. D. 12.8 cm., H. 8.9 cm.

57. Teabowl, by Kyūsetsu Miwa (the present generation Kyūsetsu). D. 12.6 cm., H. 9.4 cm.

58. Water container with seam design, by Shimbei Saka. D. 20.0 cm., H. 14.2 cm.

59. Ido type teabowl, by Kōraizaemon Saka (not to be confused with the early Hagi potter of the same name). D. 14.6 cm., H. 9.2 cm.

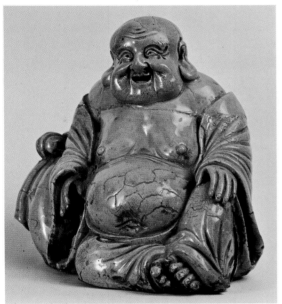

60

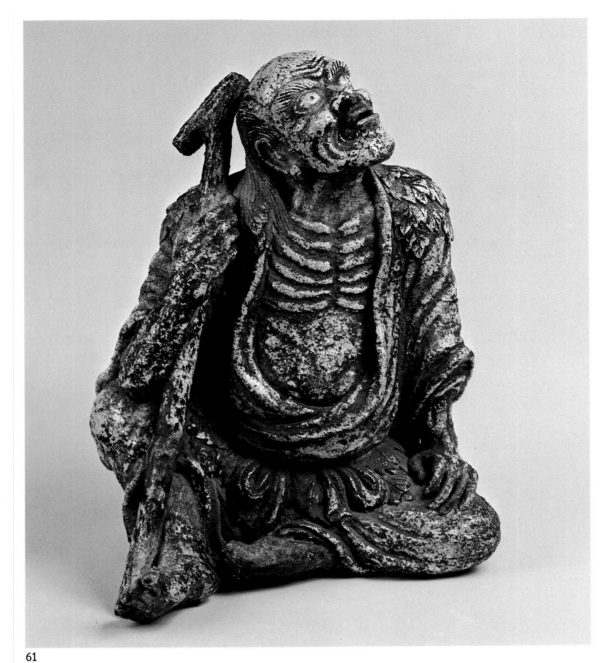

61

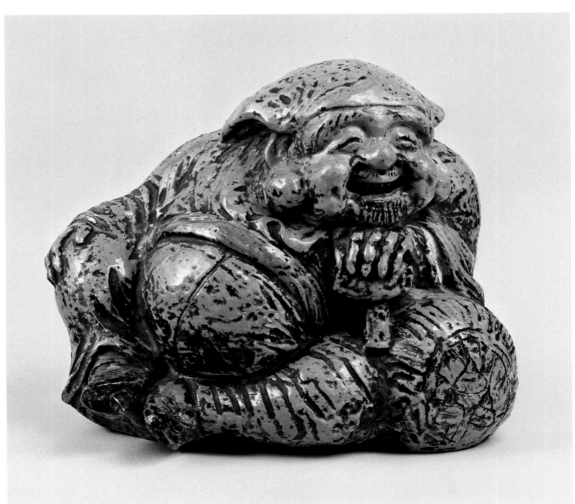

62

DISPLAY PIECES (60-62)

60. *Celadon Hotei figure. H. 26.8 cm.*

61. *Konoha Sennin figure. H. 37.5 cm. Mōri Museum.*

62. *Old Hagi, red Raku ware, Daikokuten figure. H. 25.1 cm.*

36

Plate Notes

1. *Old Hagi, Ido type teabowl, named Juzan. D. 15.3 cm., H. 8.0 cm.*
This teabowl, a copy of the Ido style, is straightforward and artless yet somehow affecting.

The bowl was made with a mixture of Daidō and Hagi local clays, to which a white slip was applied, resulting in a marked crazing.

The inside of the foot closely resembles the effect found in the Ido teabowl "Kizaemon" (a National Treasure). The color is a loquat orange, characteristic of many Hagi pieces. One gets the distinct sense from this famous bowl that it was used and cherished by some tea master of old.

2, 3. *Ido type teabowl with notched foot. D. 16.5 cm., H. 8.0 cm.*
The body of this piece is rather plain, but the deeply trimmed, tall foot, flaring out at the bottom (a style known as *bachi*—"shamisen plectrum") firmly tightens the structure of this rather expansive piece. Perhaps the bowl was made with the rather iron-rich Obata clay, for its dark red color has been beautifully brought out by the application of a thin overglaze. This type of ware is known as *beni-Hagi* ("crimson Hagi"). Some slight "crawling" of the glaze is visible around the base outside the foot ring, reminding one of fine snow that is just about to melt away. This is a splendid teabowl, which looks as though it might have been made by a Korean potter who had moved to Hagi.

4, 5. *Teabowl with white glaze. D. 14.3 cm., H. 8.8 cm.*
This bowl was completely covered with the white, rice-straw ash glaze that is one of Hagi's specialties.

The soft glaze, tinged slightly with a bluish purple, the natural curve of the lip, and the large foot are all exactly in the manner of Korean bowls. It is a quiet, unpretentious piece. Even the inside bottom is spacious and serene. Yet the wheel marks that extend up through the body of the pot are quite forceful and serve to hold the piece together. Such dignified and rich teabowls are rare. This fine example of early Hagi ware has been passed down through generations of the family of the senior retainer of the Iwakuni fief. (Iwakuni was part of Hagi domain, present-day Yamaguchi Prefecture.)

6. *Ido type teabowl, named Kan-un ("Lazily Drifting Clouds"). D. 17.2 cm., H. 9.0 cm. Hongyō-ji temple.*
This magnificent early Hagi Ido-type bowl is the biggest of its kind and is in no way inferior to the "Grand" Ido bowls made in Korea.

The clay is a thick Daidō clay. The inside bottom is broad, and the foot is in the "bamboo node" style, which lets the clay show through. The "rain spots" (spots caused when water seeps into pinholes in the glaze and causes changes in color) near the lip gives the bowl a forlorn beauty.

7. *Teabowl. D. 14.1 cm., H. 8.8 cm.*
There are a number of Hagi bowls of this shape that are thought to be of the early period. They all are slip coated in the *kobiki* manner.

This bowl's unpretentious simplicity, the "rain spots" in its glaze, call to mind the work of an immigrant potter of the early days of Hagi ware. This teabowl, like the white one in Plates 4, 5, has been passed down through the same family mentioned in the caption to Plates 4, 5.

8. *Ido type teabowl. D. 14.2 cm., H. 8.3 cm. Mōri Museum.*
This is perhaps the most beautiful of all Hagi Ido type teabowls. Its orderly shape points to the time when Korean techniques had finally taken firm root in Hagi soil. It has the loquat color typical of pieces made with Daidō clay. The numerous wheel marks near the lip add to the lightness of this refined teabowl.

9. *Teabowl, named Shimamori. D. 13.9 cm., H. 7.4 cm.*
This teabowl closely resembles bowls of the Yi dynasty in its artless execution. It was probably commissioned especially for use in the simple, "grass hut" style of tea ceremony popular among tea masters.

The trickles of glaze call attention to the artlessness of its application. That and the unglazed places add to the interest of the bowl. There is something practical about the execution of this piece that speaks of an immigrant Korean potter.

10, 11. *Teabowl with hissen (brush washer) shape and sakura kōdai ("cherry blossom foot"). D. 12.4 cm., H. 7.8 cm. Fujita Art Museum.*

This bowl is one of a matchless pair of early Hagi teabowls famous among tea masters. Both bowls have the *hissen* shape and the cherry blossom foot. The companion piece is Tago no Ura ("Bay of Tago"). The two bowls are quite alike in conception and are thought to have been made by the same potter. A third bowl, Yuki Jishi ("Snow Lion"), passed down through the Kishū branch of the Tokugawa family, might well be added to this group.

The clay is a mixture of Daidō and iron-rich Hagi local clays, producing a muted loquat color that is made the more interesting from the drops of white glaze here and there, which are the result of the glaze "crawling" during firing. The warp of the *kutsu* ("shoe") shaped lip is somehow artless. Clay shows through around the foot, which has been notched in two places, then pressed in between the cuts to make a cherry petal shape. This is an example of a Hagi bowl made in the Oribe style. An inscription on the inside of the lid of the bowl's box indicates that the piece must have been made in the early period of Hagi ware.

12, 13. *Teabowl with* hissen (*brush washer*) *shape and* higaki (*cypress fence*) *pattern. D. 15.5 cm., H. 7.5 cm.*
This oval teabowl is of a remarkably thin-walled construction. The mixture of Daidō and Hagi local clays has been refined, yielding a deep loquat color. Both sides of the lip have been rather sharply trimmed, a process called "*hissen* trimming." The slightly drooping *higaki* pattern has been made by the Mishima inlay process. These two features, and the dark lines swirling around the lower part of the bowl, lightly combine to give unity to the shape. The foot ring trimming is straightforward yet refined, and the clay that shows at the foot is quite striking.

The vermilion stamp on the base outside the foot ring (the mark of Kōshin, the fourth-generation head of the Omote Senke tea school) is extremely unusual. There are no other known examples of such a mark. Since Kōshin died in 1672, it is safe to assume that this beautiful Hagi bowl is representative of the kind of work done by the potters of the period of Kyūsetsu I. Even the box for this bowl is an old masterpiece, bearing the signature of Ittō, a master of the Ura Senke tea school.

14. *Teabowl with "rain spots," named* Tomaya ("*Rush Hut*"). *D. 15.4 cm., H. 7.7 cm.*
This is an extremely rare example of a "rain spot" Hagi bowl that could easily be mistaken for a "rain spot" piece from Yi dynasty Korea. As is typical with Hagi teabowls, it has acquired a distinct character through use. It was probably cherished and well used by some tea master.

When water seeps into pinholes in the glaze, it causes changes in color, and such stains gradually spread. This effect reminded tea masters of rain spots, and such was the name given to it. This particular teabowl closely resembles a "rain spot" teabowl of the Yi dynasty owned by the Matsunaga Memorial Museum.

15. *Copy of a* komogai *teabowl, named* Fukura Suzume ("*Fat Sparrow*"). *D. 13.8 cm., H. 9.0 cm.*
Though this easily could be a typical Korean *komogai* piece, it is in fact Hagi ware, made with Daidō clay.

The lip is bent outward, the body elongated. The inside bottom is full, with a round depression at its deepest point. The foot has been deeply trimmed in the "bamboo-node" shape, and the area inside the foot ring, which has been peaked in the *tokin kōdai* ("helmet foot") style, has a splendid "silk crepe" wrinkled effect. The loquat-colored glaze separates near the base. These features point to an immigrant potter from Korea, working in the earliest period of Hagi ware. Surely this is the finest example of a Hagi teabowl done in the *komogai* style.

16. *Old Hagi* wari-dawara ("*split rice bale*") *teabowl, named* Hōnen ("*Bountiful Year*"). *D. 14.8 cm., H. 8.0 cm.*
From very early on in Hagi, bowls were made using both the Mishima technique and *tawara* (rice bale) form. The latter involved throwing an ample, balloon-like shape then removing it and cutting it in half. A foot was attached to the bowl formed in this way. In the bowl pictured, the outside was combed, and the inside shows "wheel marks." It is orderly, yet beautiful, and lays bare the essentials of the *tawara* technique. The attached foot has been notched in three places, and there is something fresh about the touch of cobalt blue that follows the wheel marks along the inside and on the outside of the foot ring.

17. Hakeme ("*brush mark*") *teabowl. D. 15.0 cm., H. 8.8 cm. Omote Senke.*
In order to bring out the beauty of the brown color produced by Hagi's iron-rich local clay, the potter made use of the Korean *hakeme* brush mark technique by applying white slip to the base of the bowl and brushing it towards the lip. This kind of rising vertical brush mark is very unusual in Hagi *hakeme* bowls. This piece, with its quiet, uncomplicated shape, must have been highly prized by some tea master.

18. Katami-gawari ("*half-clothed*") *teabowl, named* Murasuzume ("*Flock of Sparrows*"). *D. 14.2 cm., H. 7.8 cm.*
Though this bowl was made by covering the dark Hagi clay with slip, in the *kobiki* manner, it must have been the potter's intention to leave part uncovered for contrast. The flow of pale glaze on the uncovered area adds even further to the effect of the bowl. This is a beautiful bowl of the type favored by tea masters.

19. Kobiki *teabowl. D. 16.4 cm., H. 6.9 cm.*
This Hagi teabowl could easily be mistaken for a Korean bowl of the *kobiki* type.

Unglazed areas, a common feature of *kobiki* bowls, are an integral part of this bowl's appeal. This simple, relaxed piece was probably made by an early potter and is a fine example of *kobiki* work from that period.

HAGI DISHES AND BOWLS: Hagi tea ceramics are not limited to teabowls. They also include plates and dishes for tea cakes and for *kaiseki ryōri*, the meal served at a formal tea ceremony. There is great beauty among these pieces.

At the Fukawa kiln, a number of large dishes were made. Most of them are thickly glazed with white rice-straw ash glaze and are rich in feeling.

20. *Fukawa white-glazed, lidded pot, with incised design. 21.2 × 23.1 cm.*
Lidded Hagi ware is very rare. Since there is a foot attached to this pot, it is likely that it was used for serving food to be eaten while drinking saké. The slight bluish tinge to the white glaze is peculiar to the rice-straw ash glaze used at Fukawa. This probably an early piece of Fukawa ware.

21. *White-glazed, four-footed tea cake plate. L. 33.6 cm. H. 7.6 cm.*
The interlocking diamond design is very rare among Hagi pieces. The legs, with their twisted-rope pattern, were attached after the plate was formed.

22. *Bowl. D. 28.1 cm., H. 8.2 cm.*
The clay is of the Hagi local variety. The rim of the bowl has been scalloped to suggest flower petals (a style known as *rinka*). The glaze is rice-straw ash.

23. *"Treasure boat" style bowl. L. 24.0 cm., H. 16.6 cm. Hongyō-ji temple.*
This bowl has been decorated with etched lines and attached whirl designs. Heavy crazing has appeared in the generously applied white glaze. The work was done in a proper, dignified way to represent the Treasure Boat of the Seven Gods of Good Fortune.

24. *Openwork bowl. D. 25.6 cm., H. 10.6 cm.*
One can see the influence of the Oribe tyle in this novel design. It is indeed a masterpiece among Old Hagi bowls.
Over Obata clay, a white glaze has been thickly applied. The resulting cloudy yellowish-white color, peculiar to early Hagi, could be mistaken for that of Old Karatsu ware.

25. *Fukawa white-glazed, flat dish. D. 26.8 cm.*
The ridges raised during throwing and the rim that looks as though it has been lightly marked with a brush combine to give this piece a deliberately decorated effect.

26. *Fukawa white-glazed, lotus leaf dish. D. 32.8 cm., H. 8.5 cm.*
This white, ash-glazed dish from Fukawa was made in the late Edo period. The beautifully incised lotus leaf design creates a bold effect.

27. *Four-cornered bowl. 24.6 × 19.0 cm., H. 11.2 cm. Tokyo National Museum.*
This generously shaped bowl, made with Hagi local clay, is entirely coated with white glaze.

28. *"Umbrella hat" water container, named Takitsuse ("Cascading Waterfall"). 24.3 × 20.1 cm., H. 12.7 cm.*
The rim is notched and uneven. The three deep marks along the body are very forceful. The clay is a mixture of Daidō and Hagi local clay, and on top of a wood-ash glaze, two layers of white, rice-straw ash glaze have been applied. A number of white runs flow across the broad unglazed area, calling to mind a waterfall. The name "Cascading Waterfall" is quite wonderful. This is an extraordinary piece of purely Japanese-style Hagi.

29. *Eared water container. D. of body, 16.4 cm., H. 13.4 cm.*
This is an early piece, glazed a gentle color. The impressed patterns, the incised wavy lines, and the ears are all in the Oribe manner.

30. *Water container. D. 19.1 cm., H. 13.7 cm.*
The grapevine design of this superb, lyrical piece of "picture Hagi" shows the influence of Kyoto ware.

31. *Celadon incense burner with peonies and Chinese lion. H. 23.2 cm., D. at bottom, 21.7 cm.*
This "lion atop a peony" is a very unusual design. The Obata porcelain clay is high fired. The piece bears the signature "Miwa."

32. *White-glazed flower vase with dragon handles. D. of rim, 23.8 cm., H. 30.7 cm. Mōri Museum.*
This large, wide-rimmed flower vase was made by the third-generation Saka potter, Saka Shimbei, and was passed down through the Mōri family, who ruled the Hagi fief.

33. *Incense burner in the shape of a peach. D. 5.8 cm., H. 5.5 cm.*
Tiny pebbles can be seen in the rough clay. The simple, unsophisticated loquat-colored glaze has aged to reveal a touch of red. Hagi incense burners and cases are rare. This piece is from the early period.

34. *Fukawa flower vase with* namako *("sea cucumber") glaze. D. of body, 19.4 cm., H. 37.5 cm.*
Such a wide-rimmed, large Fukawa pot, glazed in the *namako* manner, is very unusual. On top of an iron-rich red clay has been applied a mixture of wood and rice-straw ash glazes, which is a specialty of Fukawa ware. This piece is from the late Edo period.

SAKÉ BOTTLES AND SERVING DISHES: Many of the saké bottles and serving dishes made for use in the formal tea ceremony meal are in no way inferior in quality to Hagi's teabowls.

At the Fukawa kiln, many saké bottles and plates were made privately, to be sold to the common people. The difference in quality between these and those pieces done for the upper classes is immediately apparent. Yet even the common customers were of the wealthy farming class and represented an important market for the potters, who clearly devoted themselves seriously to these lesser pieces.

35. *Serving dishes with split pod shape. D. 12.8 cm., H. 6.8 cm.*
There are relatively few extant Hagi serving dishes, and among them, this split pod shape is even more rare.

"Rain spots" emerge here and there from the loquat-colored glaze, producing a feeling of loneliness. The thrice-notched foot and the sharp trimming around the base give these pieces a quiet strength.

36. *Fukawa serving dishes with abalone shape. L. 15.8 cm. W. 11.0 cm.*
Over a basic white glaze, Fukawa's special *namako* (a mixture of wood and rice-straw ash) glaze has been applied to the bumps outside the shell to create the effect of an abalone shell. These pieces are from the late Edo period.

37. *Flat dish in the form of a scroll. L. 19.4 cm., W. 13.8 cm.*
This is a most unusual design, made with a finely strained clay yielding a loquat color.

On the bottom, the name "Miwa Kyūsetsu Toshiyuki" has been etched with a nail. Toshiyuki was the fourth-generation Kyūsetsu. He, like Kyūsetsu I, studied Raku pottery in Kyoto. Signatures are rarely found on Hagi ware.

38. *Chrysanthemum plate. D. 16.5 cm., H. 3.0 cm.*
Over a mixture of Mishima clay, a rice-straw ash glaze has been generously applied. White, rice-straw ash glaze was frequently used on Hagi tableware. This piece was fired at a high temperature and is not without charm.

39. *Fukawa piragake ("scribble glazed") saké bottle. D. of body, 14.8 cm., H. 19.6 cm.*
This bottle was made at the Fukawa kiln around the end of the Edo period. The "scribbled" application of white and black glazes is quite unusual. This was not a piece made for the use of the fief lord.

40. *Kobiki saké bottle. D. of body, 10.6 cm., H. 16.4 cm.*
There are not many Hagi saké bottles from the early period. This bottle has a turnip shape and attempts to reproduce the effect of Korean *kobiki*. Yet there is something distinctively Hagi about it. Over a mixture of Daidō and local clays, a white clay slip has been thickly applied in the *kobiki* manner. Over many years of use, a number of "rain spots" have appeared, giving it a somewhat forlorn quality.

41. *White-glazed saké bottle. D. of body, 9.8 cm., H. 18.0 cm.*
The thickly applied white rice-straw ash glaze and the color of the clay harmonize well. The finger marks are of interest.

TYPES OF HAGI WARE: The following pieces are divided by technique rather than by shape or function. Here we see only the major types, but even these could be subdivided into "black glaze" (*tenmoku*), "amber glaze," "*namako* glaze," and so on. In short, it is very difficult to put Hagi ware into distinct categories.

42. *White-glazed shallow teabowl. D. 15.5 cm., H. 4.5 cm.*
The term *shira-Hagi* ("white Hagi") is used for pieces to which a white, rice-straw ash glaze has been applied. The technique was originally a means of disguising a dark clay. Many white Hagi pieces from the early period actually have a cloudy yellowish-white color.

43. *Kobiki teabowl. D. 14.0 cm., H. 8.5 cm.*
Kobiki is the most representative technique of Hagi ware. It consists of applying white slip to the leather-hard clay body and then covering that slip with a transparent glaze. As *kobiki* pieces are used, "rain spots" often form, a phenomenon highly prized by tea masters as contributing to a pot's character.

44. *Beni-Hagi ("red Hagi") teabowl. D. 12.0 cm., H. 8.9 cm.*
This color of Hagi ware is common among pieces made with iron-rich red clay.

45. *Celadon teabowl. D. 12.9 cm., H. 8.7 cm.*
From the beginning of the Edo period, Hagi celadonlike pots, made by using *isu* wood ash glaze, were frequently used as display pieces. Toward the end of the Edo period, thin-walled Hagi celadon teabowls also began to appear.

46. *Fukawa samé ("shark") glazed teabowl. D. 9.8 cm., H. 9.5 cm.*
At the Fukawa kilns, they used to use a mixture of rice-straw ash and a local clay for glazing. Since the result resembled sharkskin, the glaze came to be called *samé* ("shark") glaze. Today it is no longer used.

47. *Oni-Hagi ("demon Hagi") teabowl with hissen shape, named Chōryō (the famous Chinese warrior Zhang Liang). D. 14.5 cm., H. 7.7 cm.*
In *oni-Hagi* pieces, gravel is mixed in with the raw clay, producing a wild, uninhibited feeling.

48. *Mishima-type teabowl. D. 13.6 cm., H. 8.0 cm.*
The Mishima technique is used to create design or pattern of contrasting color in an iron-rich red clay, which fires a dark color. After a design is incised or stamped into the green pot, white ship is applied. Before it is completely dry, excess white clay is scraped away, clearly revealing the inlaid design.

49. *Gohon teabowl. D. 13.7 cm., H. 9.4 cm.*
The term Gohon originally referred to pieces made in Korea but commissioned and designed by Japanese, who sent patterns for the potters to follow. This plate shows one such basic shape.

In Gohon pieces, faint red specks are often visible in the clay. Hagi clay frequently shows this characteristic, too, and it is called *momiji* ("red maple leaves"). In Hagi ware, transparently glazed pieces that yielded such *momiji* effects came to be called Gohon because of their similarity to the Korean antecedents.

HAGI WARE BY MODERN POTTERS

50. *Low cylinder type teabowl, by Kōki Nosaka. D. 12.1 cm., H. 7.8 cm.*
"The wide inside bottom was intentional on my part, but the crystalline effect produced by the rice-straw ash glaze in the kiln added an unusual beauty." (remarks by the potter)

51. *Wide-mouthed flower vase, named Gyō-un ("Clouds at Daybreak"), by Taibi Yoshiga. D. of body, 33.5 cm., H. 35.8 cm.*
"It took three firings to achieve this cloud effect. I intend to pursue and perfect this bank of clouds at daybreak in my future work." (remarks by the potter)

52. *Seven-sided water container, by Yasuo Yamato. 17.6 cm. × 16.2 cm., H. 16.3 cm.*
"The ancient, unchanging beauty of Hagi clay has been brought out in this modern, seven-sided shape." (remarks by the potter)

53. *Ido type teabowl, by Deika Sakata. D. 15.5 cm., H. 9.0 cm.*
"Great pains were taken to recreate the Ido effect in the lip formation and the crawling of the glaze on the foot. This bowl is the result of years of study and training." (remarks by the potter)

54. *"LOVE," by Ryōsaku Miwa. H. 28.0 cm., W. 27.5 cm.*
"Inside my womb has gathered a thick, soupy substance. My work is the regurgitation of this substance." (remarks by the potter)

55. *Korean style Karatsu water container, by Tōbei Tahara. D. 18.5 cm., H. 15.1 cm.*
"A kiln-wrought beauty emerged from our special method of firing. Yet the real beauty of this piece can only have come from its accidental ash glaze." (remarks by the potter)

56. *Teabowl, by Kyūwa Miwa. D. 12.8 cm., H. 8.9 cm.*
"The form has been carefully shaped, and it harmonizes beautifully with the foot." (comment by Miwa Kyūsetsu)

57. *Teabowl, by Kyūsetsu Miwa (the present generation Kyūsetsu). D. 12.6 cm., H. 9.4 cm.*

The soft body, thickly covered with white glaze, is pulled together by the strong foot, which has been notched in three places.

58. *Water container with seam design, by Shimbei Sakakura. D. 20.0 cm., H. 14.2 cm.*
This is a copy of an Old Hagi water container with seam design, which has been passed down through the Sakakura family. This piece, which is true to Shimbei's spirit, comes very close to the original.

59. *Ido type teabowl, by Kōraizaemon Saka (not to be confused with the early Hagi potter of the same name). D. 14.6 cm., H. 9.2 cm.*
This bowl seems to have been thrown in one breath and three turns of the wheel. It looks easy to hold. The runs of glaze, and the "crawling" of the glaze at the foot are nicely done.

DISPLAY PIECES

60. *Celadon Hotei figure. H. 26.8 cm.*
There are a number of signed Hagi display pieces. This one was made by the third-generation Saka Shimbei in 1671, just after he had succeeded to the family studio name.

61. *Konoha Sennin figure, H. 37.5 cm. Mōri Museum.*
This must be the finest of the many Hagi display pieces. The attitude of the hermit, staring up in surprise at something, is frightening, bordering on the demonic.

Knowing that this piece is supposed to have been made in the early Hagi period by Saka Kōraizaemon I (Yi Kyung), and that it has been passed down through the Mōri family (Hagi's ruling clan in the Edo period) makes its strange appearance all the more affecting.

62. *Old Hagi, red Raku ware, Daikokuten figure. H. 25.1 cm.*
This is an extraordinarily large piece for Raku ware. And it is unique, as well, as a Hagi display piece. There is a yellowish tinge to the dominant red of the work, and the green sash is a truly novel and effective touch. This is thought to be the work of the potter Kyūsetsu I, founder of the Miwa house, who had been ordered by the fief authorities to study Raku pottery in Kyoto.

Higashi-no-Shin Kiln

A picture of the kiln site is shown on page 8.

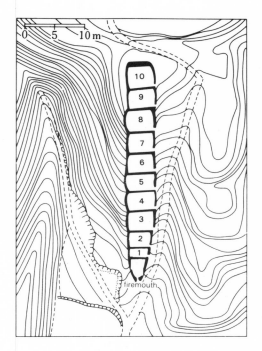

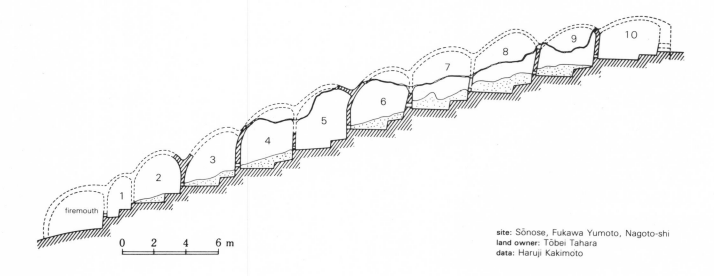

site: Sōnose, Fukawa Yumoto, Nagoto-shi
land owner: Tōbei Tahara
data: Haruji Kakimoto

Hagi Kilns and Kiln Sites

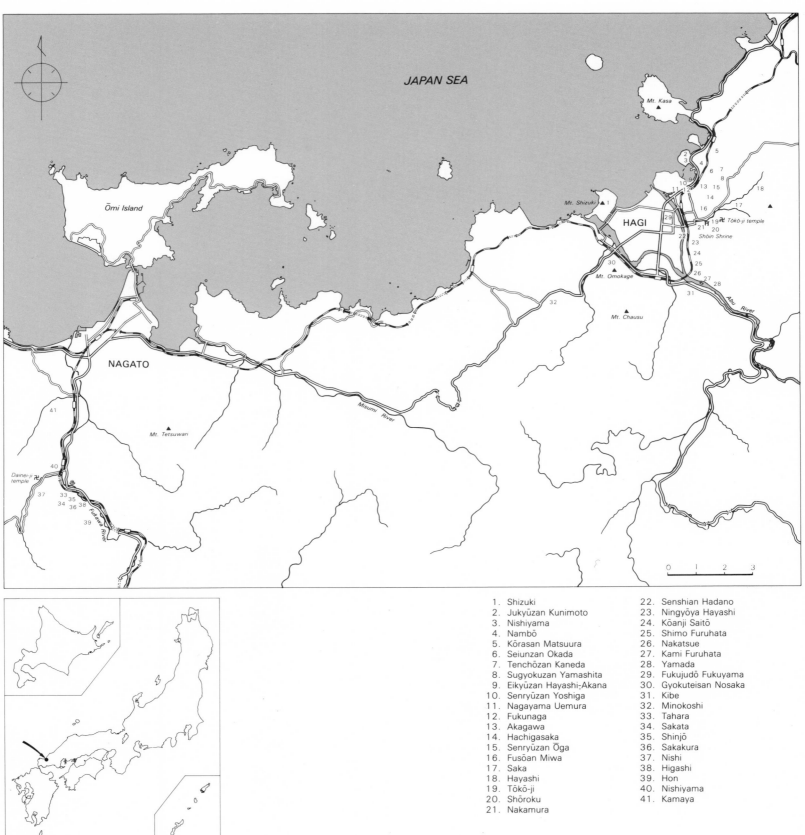

1. Shizuki
2. Jukyūzan Kunimoto
3. Nishiyama
4. Nambō
5. Kōrasan Matsuura
6. Seiunzan Okada
7. Tenchōzan Kaneda
8. Sugyokuzan Yamashita
9. Eikyūzan Hayashi-Akana
10. Senryūzan Yoshiga
11. Nagayama Uemura
12. Fukunaga
13. Akagawa
14. Hachigasaka
15. Senryūzan Ōga
16. Fusōan Miwa
17. Saka
18. Hayashi
19. Tōkō-ji
20. Shōroku
21. Nakamura
22. Senshian Hadano
23. Ningyōya Hayashi
24. Kōanji Saitō
25. Shimo Furuhata
26. Nakatsue
27. Kami Furuhata
28. Yamada
29. Fukujudō Fukuyama
30. Gyokuteisan Nosaka
31. Kibe
32. Minokoshi
33. Tahara
34. Sakata
35. Shinjō
36. Sakakura
37. Nishi
38. Higashi
39. Hon
40. Nishiyama
41. Kamaya

定価3,500円
in Japan